RELAXED

Letting Go of Self-Reliance
and Trusting God

BIBLE STUDY GUIDE + STREAMING VIDEO

SEVEN SESSIONS

Megan Fate Marshman

Harper*Christian*
Resources

Relaxed Bible Study Guide

© 2024 by Megan Fate Marshman

Published in Grand Rapids, Michigan, by HarperChristian Resources. HarperChristian Resources is a registered trademark of HarperCollins Christian Publishing, Inc.

Requests for information should be sent to customercare@harpercollins.com.

ISBN 978-0-310-11139-9 (softcover)
ISBN 978-0-310-16420-3 (ebook)

HarperChristian Resources titles may be purchased in bulk for church, business, fundraising, or ministry use. For information, please e-mail ResourceSpecialist@ChurchSource.com.

Published in association with The Bindery Agency, www.TheBinderyAgency.com.

First Printing June 2024 / Printed in the United States of America

Contents

relaxed

How to Use This Guide

Welcome, friend. I'm so glad you're here.

GROUP INFORMATION AND SIZE RECOMMENDATION

The *Relaxed* video Bible study is designed to be experienced in a group setting such as a Bible study, Sunday school class, or any small group gathering. The whole study is built around this verse: "Trust in the LORD with all your heart and lean not on your own understanding; in all your ways submit to him, and he will make your paths straight" (Proverbs 3:5–6).

Maybe you've heard that verse before, or maybe you haven't. But it's changed everything for me. I hope it will for you, too.

Throughout the study, we're going to be talking about trust. What is it, exactly, that you want to trust God with? We'll talk about that throughout our time together. At each of the seven group sessions, you will watch the video teaching. There are two parts to the video: one, my teaching, and two, a directed "Go to God" portion (don't worry, it's short!). Dig into those "Go to God" segments. They are such an amazing opportunity. I don't want you to just listen to me talk about God—I want you to go to Him yourself. After both parts of the video wrap up, you and your group will jump into some directed small-group Bible study and discussion questions. Even though there are many questions available for your small group, don't feel like you have to use them all. Your leader will focus on the ones that resonate most with your group and guide you from there.

MATERIALS NEEDED AND LEADING A GROUP

Each person in the group should have his or her own study guide, which includes a video to watch, small-group discussion questions, and daily personal studies to deepen learning between sessions. At the end of every guide is a "Go to God" section—you'll use this

in each of the group sessions. I'd also strongly encourage you to have a copy of *Relaxed*. Reading the book alongside the curriculum provides even deeper insights that make the journey richer and more meaningful.

SPIRITUAL DISCIPLINE PRACTICES

There are two sections referred to throughout this study: Tracking Trust and Go to God. Both of these sections are located at the back of each study guide.

Tracking Trust is a weekly practice of translating what your heart is dealing with into words on a page where you can follow the transformation of your heart in trusting the Lord with all things. This exercise is simple yet profound and something you can carry on in a journal or other format well after this study.

Go to God is a dual impact section. The first week includes a prayer I walk you through in the first video. This prayer is meant to be repeated throughout the five days of personal study each week. There are check-box reminders to pray in your personal study section every week. The second impact of the Go to God section involves the six other spiritual discipline practices I introduce weekly at the end of each video. You will want to turn to this section in the back of your guide during this portion of the video each week for your personal practice of each discipline.

FACILITATION

Does that sound like a lot? Well, don't worry. You can relax. God's got this, and He's got you, too. He already knows how this is going to go—not just for you, but for your whole group. From that perspective, here are three things to keep in mind about this study.

1. First, **the real growth in this study will happen during your small-group time.** This is where you will process the content of the message, ask questions, and learn from others as you listen to what God is doing in their hearts. So, one of the most important things you can do is . . . **show up.** Because you matter! Commit to the group and attend each session so you can build trust with the other members of your group.

2. Second, remember that as much as small groups can be a deeply rewarding time of intimacy and friendship, they can also be a disaster. **Work to make your group a "safe place."** That means first being honest about your thoughts and feelings as well as listening carefully to everyone else's opinion. **(Note: If you are a group leader, there are additional instructions and resources in the back of the book for leading a productive discussion group.)**

3. Third, **resist the temptation to "fix" a problem someone might be having** or to correct his or her theology. That's not what this time is for. In addition, make sure you keep everything your group shares confidential.

All this will foster a rewarding sense of community in your small group and give God's Spirit some space to heal, challenge, and engineer life transformation.

TIMING

Following your group time, there are personal studies that will help you delve deeper into the session content. These are split up into five "days" over six "weeks"—but I know that timeline might not match what your group does. You can do more than one "day" of personal study in a given day. For example, you may wish to complete the personal study all in one sitting or to spread it out over a few days (for example, working on it a half-hour a day on four different days that week).

But remember what I said about how much your presence matters to this study. If you are unable to finish (or even start!) your between-sessions personal study, **still attend the group study video session.** We are all busy, and life happens. You are still wanted and welcome at the group even if you don't have your "homework" done.

So. Do you want to trust Him more?

He's going to take care of *everything*.

session 1
Trust in the Lord

Trust in the LORD with all your heart, and lean not on your own understanding.

PROVERBS 3:5

Start Here

PRAYER

> **LEADER:** Pray before you open your study time together, sharing whatever is on your heart with God. Invite others to pray, too.

Tracking Trust

> **ALL:** Flip to the back of your guide, page 172, and record your response to the prompt. As a group, begin each week together reflecting on the transformation you see through your responses on these pages.

What is one thing you want to trust God with during this study?

Definition: Trust

to rely upon or place confidence in someone or something (usually followed by in or to); to have confidence; hope**.**

Watch Video

Scripture Covered in this Teaching

Proverbs 3:5–6; Genesis 3:7–13, 2:25; Romans 5:8

> **LEADER:** Before starting the video, read the following aloud.

There's not going to be a test on any of this. You don't have to write something after each point. Use the margins if you need them. Feel free to pull out your own journal, or to just sit and listen— whatever helps you engage.

Trust in the Lord, not yourself.

Autonomy in this context can be summed up in one word: self-reliant.

We can trust in the Lord because He is sovereign.

The goal of our prayer is not perfection, it's nearness to Jesus.

Trust in the Lord begins with honesty.

Becoming relaxed is the byproduct of trusting in Him, not ourselves.

Go to God

Turn to the "Go to God" Session 1 section on page 176 in the back of the workbook to engage with this week's spiritual discipline.

Discussion Questions

Now, spend some time with the following questions. Don't rush to get through each one. Use these questions in the way that best serves your group. Instead of going in order, you can choose to discuss the questions that are most relevant and interesting to you.

1. What stood out to you from the video—was any particular statement, idea, or Scripture encouraging to you?

2. Open your Bible to **Genesis 3:1–10** and have someone read the verses out loud. Take a moment to imagine God's heart in that moment—how would you describe it? How does the human response to sin differ from God's response to sin?

3. What are some practical ways we can reveal ourselves to God, resisting the impulse to hide from Him?

4. What do you think Megan means by "performance" in prayer—what kinds of actions and attitudes are displayed by someone who is "performing"?

5. Respond to the phrase: "If you want a boring prayer life, spend it trying to be good in prayer rather than being honest."[1]

6. What does "trust in myself" look like? What kinds of words and actions come from a person who is relying on themselves?

7. Read **Philippians 1:6** together. Who is doing the work? How does it feel to realize where the responsibility lies?

1. Kyle C. Strobel and John Coe, *Where Prayer Becomes Real: How Honesty with God Transforms Your Soul* (Grand Rapids: Baker Publishing Group, 2021).

Closing

What are you going to use as your reminder this week to pray?

The personal study this week includes five guided days of prayer and Scripture study—there's a note from Megan at the beginning of the section to help you get started.

When and where is the next meeting?_____

Write down the names of your group members so you can pray for them by name throughout the week.

All God's People Said . . .

LEADER: Pray or invite someone else to pray—the prayer below is optional.

Lord, we come before You in gratitude, thanking You for this time together and thanking You for the gift of Yourself. We want to trust You. Help us to trust You more. *Amen*

session 1
Trust in the Lord

Note from Megan

Hey.

Before you start working on these pages, I just want to remind you that wherever you are at right now is exactly where God is going to meet you. Each day, you'll go through the prayer you learned during the group session and then take time to read His word.

Maybe you're excited about meeting with God this way, and you've already penciled in the time every morning for the next week. Maybe you really don't think this kind of prayer is going to "work" for you. You've tried to pray—a lot—and the habit never stuck. Why should this time be any different?

Your answers to these exact questions may be a great place to begin your prayer. Why? Because they're honestly where you're at. Speaking them to God IS TRUSTING Him with right where you're at.

Let me invite you to keep testing this pattern of prayer we talked about—show up, peel away, let your mind wander, listen, and obey. Because I do think that coming to Him like this will help you trust Him.

Why?

Because offering yourself to Him is an act of trust—when you show up, you're **trusting Him with all your heart**.

When you peel away those other layers of your identity, acknowledging that belonging to Him is the most important part of who you are, you're **leaning on His understanding, not your own**.

When you let Him in on all of your stray thoughts, no matter what they look like, **you're submitting all of your ways**—even the ones you aren't proud of—to Him.

When you listen to Him and obey Him, He's the one in charge of your path. **And He will make your paths straight**.

Now, before I let you go, I want to give you some encouragement about how to proceed and go over the resources available to you in this workbook.

There are two opportunities being held out to you: **Going to God daily** and working through the 5 **personal study days**.

Going to God daily is just that—a reminder to turn your heart toward Him every day (or five days out of seven, like I said in the video 😉).

How much time should "going to God" take? Well, that's up to you. But consistency is key. Try starting with just five minutes each morning.

Personal study days can be split up differently—you could do one "day" after you Go to God in the morning. Or you could Go to God each morning but complete these personal studies in larger chunks throughout the week.

Your experience could look like any of these:

1. Go to God each morning and do one personal study day right then, too.
2. Go to God each morning, do a personal study later in the day.
3. Go to God each morning, complete personal study days in larger chunks during quiet spots throughout the week.

Think through what will work best for you before you dive in—but remember, you can relax. You can switch up your plan. We're on this path together, friend—looking straight at Him, asking for His help in everything, trusting Him with our capacity to trust in Him at all.

Megan Fate Marshman

day 1
Trust in the Lord

Today is _____

GO TO GOD DAILY PRAYER (p. 176) ☐

Just in case you forgot to trust in the Lord this morning . . . here's a reminder, on me!

> Show up. . . .
> Peel away . . .
> Let your mind wander . . .
> Listen and obey.

Amen

In the group session, we started talking about trust. It's a huge part of this study. And as you're thinking about what you learned in that first session, I want you to think about the things that make trust difficult. It's not easy to trust—not for anybody. I want to invite you to read a few paragraphs from my book, *Relaxed*.

Read (*Relaxed*, pp. 9–10)

You should probably know right off the bat that I'm a widow. My husband, Randy Marshman, died of a surprise heart attack and went home to heaven at age thirty-six on February 21, 2021. I know that learning this feels abrupt, alarming, and wild. It still feels that way to me.

Within months of his death, I noticed a tendency in myself: I took pride in not needing anything or anyone. You'd be surprised at what you can do after a few YouTube searches. So far I've fixed cabinets, changed windshield wipers, carried two sleeping boys off an airplane while towing three suitcases, and fixed a sprinkler, all without asking anyone for help. This stubborn independent streak is common among widows. We hate being dependent. Humanity at large has similar tendencies.

In our culture, independence is a virtue, but it's a hindrance in the Christian faith. Being dependent on the Lord is the root of what it means to follow Him, and yet my friends, coworkers, and family—Christian or not—will forever encourage me when I accomplish something unaided. Our cultural norm of "you are better if you can do this by yourself" isn't going anywhere. If we don't understand it, we'll continue being tempted toward autonomy: the tendency to live our lives, even our faith, trusting in ourselves alone. If we continue living autonomously, we'll miss out on some really beautiful parts of faith—things like intimacy with God, contentment, humility, and peace—and, rather, we'll continue the cycle of self-reliance, stress, and anxiety. When you boil it down to its essence, faith is nothing more than dependence. It is acknowledging that God is God and we are not, and that we need Him for absolutely everything. It is relying on God for what we are tempted to rely on ourselves for. The struggle of dependence is not a matter of who is in control, for God is the one truly in control. It's about what kind of relationship we want to have with the one who is in control, a choice between a competing or submitting relationship. A dependent relationship with God goes beyond a mere power dynamic; it delves into the nature of the relationship.

You might not have the same roles as I do (it'd be a little weird if they were exactly the same . . .). But I bet there are some roles you play that make trust look unappealing.

Name a few of your roles.
Your job, your family, who you take care of—that kind of thing.

Do any of these roles carry the pressure to do everything yourself?
Circle those.

Remembering that God is gentle and kind with you, read through the Scriptures referenced during the group study time.

Proverbs 3:5–6; Genesis 3:7–13; Genesis 2:25; Romans 5:8

Which of these Scriptures is speaking to you the most today?
Write out the full verse(s) you chose here.

Look at the roles you circled again—is there one that is particularly heavy on your heart?

Now, look at the verse you chose to write out. What do those lines of Scripture tell you about who God is? Visualize giving over your burdens to Him. Write out what you're giving Him, trusting in His power to transform.

Prayer Prompt

Write a prayer to Him, using words from the verses you studied today.

day 2
Trust in the Lord

Today is_____

GO TO GOD DAILY PRAYER (p. 176) ☐

Read His Word

Find **Proverbs 3** in your Bible. Read **verses 1 through 20**, or even the whole chapter. Verses 5 and 6 will be very familiar already, but let's look at the passage with a wider lens.

> Write out a few verses that stood out to you, whether they were encouraging, or confusing, or meaningful for some other reason.

Wisdom—it's what the book of Proverbs promises to us. But what is wisdom? Is wisdom knowing what to do and when to do it? As you already know, life is full of situations that require more than a simple response of "yes, do the thing!" or "no, don't do that!" There are often many factors to consider. This reminds me of what Brian O'Driscoll said, "Knowledge is knowing that a tomato is a fruit. Wisdom is knowing not to put it in a fruit salad."[1] How do we learn to manage the distinctions? We learn it over time from someone wiser than us.

There is no set of instructions that will give you a "yes" or "no" to every choice you encounter. Instead, God offers us something better: the opportunity to grow in wisdom. Wisdom doesn't really mean always knowing what to do . . . wisdom is knowing who to ask.

Definitions

Autonomy
the quality or state of being self-governing; self-directing freedom and especially moral independence

Dependence
the quality or state of being dependent; the quality or state of being influenced by or being subject to another; reliance; trust

We can't be wise if we insist on autonomy. Anyone who is really and truly wise is exercising dependence on God in everything they do: "for the LORD will be at your side and keep your foot from being snared" (Proverbs 3:26). Autonomy is foolishness in practice; without God, we wander into dangerous territory.

Read over **Proverbs chapter 3** again. As you read, use the chart to categorize some specific phrases as the result of "autonomy" or "dependence." If you want to add more phrases to your chart, turn to **Colossians 3:1–17**.

1. Niall Kelly, "Brian O'Driscoll has explained the story behind his legendary 'tomato' quote," The 42, April 16, 2015, https://www.the42.ie/brian-odriscoll-tomato-fruit-salad-quote-2051370-Apr2015/.

AUTONOMY	DEPENDENCE
Example: despise the Lord's discipline	Example: inherit honor

Most of us can't say that our lives are lived either in complete autonomy or complete dependence. So often, we're a mixed bag—we rely on God in one situation, and we insist on our own way in another. Or we go back and forth between autonomy and dependence right in the space of five minutes! That's okay. We can relax and share that with God, too.

Can you name an area of life where you live in dependence? What about autonomy? Any that would be best described as both? You can look back at the definition boxes to help you decide. List a few of them below.

AUTONOMY:

DEPENDENCE:

SOME OF BOTH:

In your life, what are some tangible results of autonomy? What about dependence?

Prayer Prompt

Write out a prayer using some of the lines of Scripture you read today, asking God to help you move toward dependence.

day 3
Trust in the Lord

Today is_____

GO TO GOD DAILY PRAYER (p. 176) ☐

More from His Word

Yesterday we read Proverbs 3 and pondered wisdom together. Wisdom leads to dependence—trust in God—instead of autonomy—trust in ourselves. And when we rely on Him, God does incredible things within us and through us.

Romans 12 shows us some beautiful specifics about what happens when we are in that state of dependence on God. Before we get into that, I just have to mention this, because it's incredible. In the final verses of Romans 11, right before this chapter you'll read, Paul wraps up an incredible account of history: from Adam, to Israel, to Jesus Himself. Paul ends his account by praising God's wisdom:

Oh, the depth of the riches of the wisdom
and knowledge of God!
How unsearchable his judgments,
and his paths beyond tracing out!

ROMANS 11:33

We trust in the Lord with all our hearts because He is *trustworthy*.

Read **Romans 12** now with the understanding that, in a state of dependence, we can offer ourselves to our trustworthy God completely. The actions you'll read about aren't a to-do list. Instead, it's a "He will" list. He will accomplish these things in us—He will serve through us, love through us, hope through us.

As you read the chapter, write down specific phrases in the chart below.

I WILL	HE WILL
Example: offer my body as a living sacrifice	Example: assign a measure of faith

This list in Romans 12 is incredible. If you're looking at the list thinking, "I haven't done any of this," you can relax. God is working in you, right now, helping you become more dependent on Him. You can trust Him with your own process of growth—He is always working. But before you go, I want to challenge you. Instead of fixating on what you haven't done, think about what *He has done* in you. I mean, here you are, going through this study, *right now.* Ask God to bring to mind some things He has done in you and through you for others. Write them here.

Prayer Prompt

Write a few lines of prayer to God, thanking Him for the ways He *has* worked through you in addition to thanking Him in advance for the ways He *will* work through your dependence.

day 4
Trust in the Lord

Today is_____

GO TO GOD DAILY PRAYER (p. 176) ☐

Rely on Him

Let's bring these days of personal study together. This is going to require some flipping back and forth, but hopefully you'll end up with some new perspective.

> Now, back to Day 2 (page 16). What phrases from **Proverbs 3** did you put on the "dependence" side of your chart?

On Day 3 (page 19), you wrote out phrases from **Romans 12** in another chart. What did you place under the heading "He will"?

What has He promised to do in you?

Fill in the chart below. Write any reasons you're holding back from God on the left. Write the reasons why you can trust Him on the right. These don't have to be complete sentences or worded perfectly. *Relax*—He knows it all already. You can't surprise Him. Use the pieces of Scripture you wrote under "dependence" and "He will" to help you come up with reasons you can trust Him.

I'm holding back from trusting God with	I can trust God with
because . . .	because . . .
I'm holding back from trusting God with	I can trust God with
because . . .	because . . .
I'm holding back from trusting God with	I can trust God with
because . . .	because . . .

Prayer Prompt

God is trustworthy, but He knows that trust isn't easy for us. He's patient with us. Write a prayer, asking God to help you trust Him with whatever you wrote down in your chart.

day 5
Trust in the Lord

Today is _____

GO TO GOD DAILY PRAYER (p. 176) ☐

Reflect and Relax

Did you remember to Go to God most days this week? Was committing to a daily prayer discipline easy, or difficult, or somewhere in between? You can be honest. Remember, that's where trusting God begins.

After a week working through acknowledging where you choose autonomy and where you find relief in dependence, write out new definitions in your own words here.

AUTONOMY:

DEPENDENCE:

Have you felt yourself becoming more relaxed?

Can you recall a moment from this past week when you chose to lean into that relaxed life with Jesus instead of grasping for control? Describe that moment here.

You can do this in any way you want—you can draw a picture, or make a list, or write down a few words you felt God gave to you.

If not, why do you think that is?

Write a scripture from one of the personal study days that was significant to you on a sticky note. Put it somewhere you'll see it consistently over the next few weeks (the dash of your car, bathroom mirror, the fridge, etc.)

Looking Ahead

Something to start thinking about for the next group session: How would you know what is in someone's heart? What kinds of evidence would you look for?

What's a question that came up in your days of personal study you'd want to ask the rest of the group?

Take a moment to pray for the next group meeting and the members of your group.

relaxed

session 2
With All Your Heart

Jesus replied: 'Love the Lord your God with all your heart and with all your soul and with all your mind.'

MATTHEW 22:37

Start Here

LEADER: Pray before you open your study time together, sharing whatever is on your heart with God. Invite others to pray, too.

Tracking Trust

ALL: Flip to the back of your guide, page 172, and record your response to the prompt. As a group, begin each week together reflecting on the transformation you see through your responses on these pages.

What was the one thing you wrote down last week—the one thing you're trying to trust God with during this study? After a week of prayer and study about trust, would you phrase it any differently?

If you're ready, share your "one thing" with the group.

Definition: Heart

A hollow muscular organ that pumps the blood through the circulatory system by rhythmic contraction and dilation; The central or innermost part of something.

Watch Video

Scripture Covered in This Teaching

Proverbs 3:5–6; Matthew 22:37; Proverbs 4:23; Mark 9;
Jeremiah 29:13; John 15; Romans 7 (referred to in Go to God)

> **LEADER:** Before starting the video, read the following aloud.

There's not going to be a test on any of this. You don't have to write something after each point.
Use the margins if you need them. Feel free to pull out your own journal or to just sit and listen—
whatever helps you engage.

We need to trust God with everything that is in our *hearts*.

Our behavior comes from the depths of our hearts.

Even though God is always present, our experience of Him changes over time.

The first step of spiritual growth is opening our hearts to God.

God does the work of transformation in our hearts.

Go to God

Turn to the "Go to God" Session 2 on page 178 in the back of the workbook.

Discussion Questions

Spend some time with the following questions. Don't rush to get through each one. Use these questions in the way that best serves your group. Instead of going in order, you can choose to discuss the questions that are most relevant and interesting to you.

1. What stood out to you from the video—was any particular statement or Scripture encouraging to you?

2. Find **Romans 7:15–25** and read it together. Paul writes, "For what I want to do I do not do, but what I hate I do." Relate this passage to my analogy about the tree: The heart is the root, the behavior is the fruit. What lives in our hearts and causes us to grow bad fruit?

3. Name a few reasons you might resist looking into the depths of your own heart.

4. Why does understanding our own hearts help us love God more?

5. How does God redeem the darkness and sin in our hearts?

6. Come up with some simple definitions for the "desolation" and "consolation," terms that describe our experience of spiritual growth based on what I taught in the video and on what you may have learned before.

7. Who's going to work the most to grow you spiritually, and how does that reality help you live in a more relaxed way?

Closing

LEADER: After the discussion time ends, read this closing question, and ask volunteers to share their responses and briefly review what comes next.

Is there a time and place where you can be truly alone with God while you search your heart with Him?

The personal study this week includes five guided days of prayer and Scripture. Take some time to go through the "Go to God" exercise Megan described at the end of the video if you haven't already.

When and where is the next meeting?_____

Write down the names of your group members so you can pray for them by name throughout the week.

All God's People Said . . .

Father, You know our hearts and You want to fill them with Your love. Search our hearts. Empower us to share it all with You. Help us to not be discouraged or dismayed, because our growth and our hearts are in Your capable hands. *Amen*

session 2
With All Your Heart

Note from Megan

You're back!

I'm glad. Thank you for showing up for this time. God will use it for His glory and for our good.

I'm not trying to put the pressure on you—I'm trying to show you where the pressure belongs. I used to think that my spiritual growth was all on me. So, I went after it—I prayed, I read the Bible, I went to church, I served others . . . but the enthusiasm ran out for these spiritual disciplines, as great as they are. I didn't feel close to God anymore. And I thought that my feelings were the best metric for how well I was growing in Christ. But I felt nothing. And I was trying to grow, really, really hard.

Our growth doesn't work that way.

> *"For we are God's handiwork, created in Christ Jesus to do good works, which God prepared in advance for us to do."*
>
> EPHESIANS 2:10

We're not doing the work. We ARE the work. In this, growth becomes something completely different. It's not a contest—it's healing. And wholeness. And a totally new experience of the depth of His love.

This week, at least once, I hope you take the opportunity to Go to God and let Him show you your heart. You're going to discover things about yourself, but most importantly, you're going to realize that He wants to be with you in all of it. Everything. The important stuff. The small stuff. The hard stuff. The great stuff. You don't have to do a single part of your life alone.

And He won't be surprised by *anything*.

Continue to pray every day. You can track how that's going in the week 2 "Go to God" section (page 178). This isn't supposed to make you feel guilty. It's an opportunity to see what's going on in your life and your heart.

Here's a reminder. The experience of this study could look like any of these:

1. Go to God each morning and do one personal study day right then, too.
2. Go to God each morning, do a personal study later in the day.
3. Go to God each morning, complete personal study days in larger chunks during quiet spots throughout the week.

Think through what will work best for you before you dive in—but remember, you can relax. You can switch up your plan.

You can trust Him with your whole heart. You can even ask Him, "God, I prayed for three days in a row and then I forgot for the rest of the week—what's going on with me? Reveal my heart."

Search your heart with Him this week. And relax—He's going to love you toward growth.

[signature]

day 1
With All Your Heart

Today is _____

GO TO GOD DAILY PRAYER (p. 178) ☐

Review

Why do the patterns of sin linger in our lives, even when we know that they're sinful? Even when we desperately want to change?

I think it's possible to approach this question with curiosity instead of shame. God already knows and sees you—all of you—and He loves you. He wants to change and heal your heart. If the term "spiritual growth" brings up any shame or burden in you, I hope that changes this week. Once, when I was listening to a Dallas Willard interview, it dawned on me: The true measure of your spiritual disciplines is how you feel when you don't do them. Do you feel **guilty** or do you feel **thirsty**?

You can trust God with all your heart. He is the one who can do the work of transformation in the heart.

Okay. So—why don't we change when we want to change? Let's get curious. Here's a few paragraphs from *Relaxed* to get us thinking about this question today.

Read *(Relaxed,* pp. 30–31)

There's a gap, what theologians call the "sanctification gap," between who we are in Christ and who we are on a daily basis. Too often we hear a message at church and agree with the teaching, but we walk away unchanged. We don't realize how the message applies to us personally, and even if we do, we likely don't know how to live it out. Like how do you really put off anger or pray without ceasing? Despite the constant spiritual input, our patterns of sin linger.

Imagine you've signed up for a new gym membership and, on your first day, you get an amazing orientation from a charismatic personal trainer about all the weight you will lose, the muscle you will gain, the abs you will have, and how you're going to feel about yourself. You leave your orientation excited about your new fitness journey. You come back the next day, and the same personal trainer meets you at the door and gives you the exact same orientation. And this goes on indefinitely. Every day, you hear what you're going to (and need to) do but you never learn how to do it.

We know we're not supposed to sin, and we really don't want to sin. But we still do—not because we're "not trying hard enough" but because our hearts are hidden from us. We don't know why we do what we do. One way we try to hide and cover (though not intentionally—hidden heart!) is to try to cover up any part of our lives that doesn't feel right with good behavior. It won't work. We need to get to the roots of the issue.

Can you relate to this? Name a spiritual discipline or practice that you were excited about at the outset but didn't go anywhere—some examples could be reading the whole Bible in a year or finding a great spiritual mentor.

Listen—we've all been there. All of us have a list of things that did not go the way we thought they would go. We so often judge ourselves based on these "failures" and forget to give credence to the fact that we're still reaching out, still looking for Him, still trying.

That right there says something about your heart and the work He's doing in it.

He's still working—even in the things that we think "didn't work." If you can't see any change, maybe the change is happening somewhere hidden—in your heart.

Look up these three verses that we covered in the group study.

Proverbs 4:23; Jeremiah 29:13; John 15:5

Write out one of these verses in the space below, remembering that it's God who changes hearts.

Prayer Prompt

Write a prayer to Him, thanking Him for turning your heart toward Him.

day 2
With All Your Heart

Today is _____

GO TO GOD DAILY PRAYER (p. 178) ☐

Read His Word

What does Jesus want from us? Sometimes we think this can be answered with the usuals: He wants us to pray. He wants us to read our Bibles. He wants us to serve our communities. And yes, He does! But there's something underneath all of that, something that holds those external actions together.

> Turn to **Matthew 22**. Read **verses 34–40**.
> Jesus says the greatest commandment is: _____
> And the second is: _____

Now, we're going all the way back to the book of Deuteronomy in the Old Testament to get more context.

After decades of wandering around in the desert, the Israelites are finally about to enter the land that God has promised them. Their leader—Moses—is giving the people a message from God.

Read **Deuteronomy 6:1–9** slowly. Write out **Deuteronomy 6:5**, the verse that is so similar to Jesus' answer to the "expert in the law" who was testing Him.

Throughout His own childhood, Jesus would have heard the words from the songs, prophecies, and laws of the Old Testament. His parents were faithful Jews. They would have been mindful of the instruction in Deuteronomy 6:7: "Impress them on your children. Talk about them when you sit at home and when you walk along the road, when you lie down and when you get up."

The "expert in the law" mentioned in Matthew 22:35 would have grown up hearing Scripture, too. Jesus and this man would both have known, backwards and forwards, the books of law given to Moses and the other prophets. But their approach to the law was radically different.

Let's think through that difference.

Do you remember the tree drawing from the Session 2 video?

Replicate that drawing in the box below. Draw a tree, with roots at the bottom and fruit on the branches. You can draw a heart by the roots, or just label them "heart." Label the fruit "behavior."

Draw two arrows. The first arrow starts in the roots and ends at the fruit, the second arrow starts in the fruit and goes back to the roots.

Which arrow describes Jesus' approach to the law? Which arrow describes the approach of the "expert in the law"? Label the chart.

Look again at **Deuteronomy 6:6**.

> *"These commandments that I give you today are to be on your* _____*."*

We cannot change our hearts by just knowing all the things we're supposed to do. If we want to change, we have to reveal our hearts to Him first.

Prayer Prompt

Write out a prayer using some of the lines of Scripture you read today, asking God to help you love Him with all your heart.

day 3
With All Your Heart

Today is_____

GO TO GOD DAILY PRAYER (p. 178) ☐

More from His Word

Yesterday, we looked at one of the places Jesus would have heard the commandment, "love the Lord your God with all your heart and with all your soul and with all your mind" (Matthew 22:37).

Today we're going to look at **Mark 9:14–29**. Read the passage slowly to yourself.

In the space below, write out the conversation between Jesus and the boy's father. You can copy the text or paraphrase in your own words.

In this story, does the father of the boy fulfill Jesus' greatest commandment? If so, how?

Here's my take on this. In Mark 9:24, the man says, "I do believe; help me overcome my unbelief!" He's recognizing that his heart is divided: Part of him believes and part of him doesn't. But by declaring this aloud, the man gives Jesus both parts of his heart: the part that trusts **and** the part that doesn't trust yet.

And if Jesus has all the fractured pieces of your heart, you **are** giving Him your heart.

Flip back to the Tracking Trust exercise that you're filling out during the group study (page 172) and write what you're trying to trust God with below.

I'm trying to trust God with _____

Come before Jesus, just like the boy's father did, with whatever it is that you're trying to trust God with.

In the left side of the chart, list a few pieces of evidence that you do believe God's helping you with.

In the right side of the chart, list a few ways you need help overcoming your unbelief.

I DO BELIEVE	HELP ME OVERCOME MY UNBELIEF

Now, draw a giant heart around the whole chart. Trust God with your whole heart—what you believe in and what you are still struggling through.

Prayer Prompt

Pray over the heart chart you made during today's time of study, recognizing that God knows about your belief and your unbelief. Thank Him for loving you completely.

day 4
With All Your Heart

Today is _____

GO TO GOD DAILY PRAYER (p. 178) ☐

Search Me and Know Me

We're going to search our hearts with God today like we did in the "Go to God" time of our group session (page 178).

Here's what I do: I draw a heart and extend spokes from it. In a moment of quiet reflection, I invite God to search my heart. Words, emotions, mistakes, grief, people—anything that surfaces gets jotted down, each attached to a spoke. "Tired. Excited. Insecure. Worried about making everything all about me. Shameful about a mistake. Concerned for my son. Curious about lunch."

Once I fill up the spokes, I take another spin around the wheel of my heart with God. I write a sentence about each concern, then open my mind and heart to God to remind me of something true, penning it down. Then I let God help me weave the two together to form the third sentence.

- "Tired: God, I'm doing too much. I know You're always working. Help me rest in Your work instead of feeling bogged down by mine."

- "Concerned for my son: God, I don't know how to control him. You love him. Help me love him like You do, without trying to control the uncontrollable."

- "Shameful about a mistake: God, I'm so sorry. You've forgiven me."

Every time I share my heart with God, His heart meets mine in that sacred exchange. While sharing my heart doesn't change the situation, finding God's heart often transforms my heart toward it. Relax; He's in control. You're fully forgiven and accepted already.

Are you ready? Take out another piece of paper and draw a heart on it—spend ten minutes (or more!) searching your heart with Him.

What did He show you?

Jesus taught that we should "love the Lord with all your heart and with all your soul and with all your mind."

During our personal study this week, we looked at that commandment in several ways. We read the passage from Matthew's Gospel and we looked back to some verses from the Old Testament. Yesterday, we read about the father in Mark 9:14–29. He fulfilled that commandment by giving Jesus everything in his heart—even the unbelief.

Jesus wants us to love Him with all our hearts.

Sometimes we think this means that we have to get everything right in our hearts before we can take them to Him. We want to give Him a good offering—a clean, beautiful, holy heart. We want to give Him something that we can feel good about.

But that's not what He's asking for—He's asking for all of our hearts, just as they are, right now.

But we can make a wholehearted offering of broken hearts.

Find **Psalm 51** in your Bible. Read the whole Psalm and write out two or three verses that speak to you.

David says in Psalm 51:17,

> *"My sacrifice, O God, is a broken spirit;*
> *a broken and contrite heart*
> *you, God, will not despise."*

Just like the father in Mark 9, you can offer God a heart that is broken and contrite and even contradictory.

Have any surprising or contradictory behaviors come to light as you've asked God to search your heart with you this week? Fill in the following chart and see the connection between your behaviors and your heart. You can look at your Go to God exercise on page 178 for some ideas.

MY BEHAVIOR	WHAT'S IN MY HEART
(example: yelling at other cars on the freeway)	(example: anger, fear)

Prayer Prompt

Take a moment to let this sink in: God loves you, as you are, right now. No matter how you've behaved. No matter what the roots of those behaviors are. God sees all of your heart, knows it entirely, and loves you completely. Write a prayer to God, taking into account the new things He has revealed to you about your own heart.

day 5
With All Your Heart

Today is _____

GO TO GOD DAILY PRAYER (p. 178) ☐

Reflect and Relax

What does your prayer time look like now, at the end of this second week? Where are you praying—is there a location that works the best for you?

After a week of study and letting God search your heart, how would you define "heart" in your own words?

Heart: _____

Have you felt yourself becoming more relaxed? If yes, in what ways? If no, what do you think is still holding you back?

Can you recall a moment from this past week when you chose to lean into that relaxed life with Jesus instead of grasping for control? Describe that moment here. You can do this in any way you want—you can draw a picture, or make a list, or write down a few words you felt God gave to you.

Write a scripture from one of the personal study days that was significant to you on a sticky note. Put it somewhere you'll see it consistently over the next few weeks (the dash of your car, bathroom mirror, the fridge, etc.).

Looking Ahead

Something to start thinking about for the next group session: Imagine standing before God. What do you think that would be like?

What's a question that came up in your days of personal study you'd want to ask the rest of the group?

Take a moment to pray for the next group meeting and for the members of your group.

session 3
Lean Not on Your Own Understanding

"Nothing in all creation is hidden from God's sight. Everything is uncovered and laid bare before the eyes of him to whom we must give account."

HEBREWS 4:13

Start Here

LEADER: Pray before you open your study time together, sharing whatever is on your heart with God. Invite others to pray, too.

Tracking Trust

ALL: Flip to the back of your guide, page 172, and record your response to the prompt. As a group, begin each week together reflecting on the transformation you see through your responses on these pages.

How has your perspective shifted on the one thing you're really hoping to trust God with during this study?

If you're ready, share how your perspective is changing with the group.

Definition: Impute (verb)

to lay the responsibility or blame for (something) often falsely or unjustly; to credit or ascribe (something) to a person or cause

Watch Video

Scripture Covered in This Teaching

Proverbs 3:5–6; Philippians 2:13; Revelation 4; Isaiah 6; Luke 12:2; Hebrews 4:13–16; 2 Corinthians 5:21; Romans 6:23; Hebrews 12 (referred to in Go to God)

There's not going to be a test on any of this. You don't have to write something after each point. Use the margins if you need them. Feel free to pull out your own journal, or to just sit and listen— whatever helps you engage.

We're tempted to despair, to act immorally, and/or to figure everything out ourselves.

We aren't relaxed because we're trying to figure it all out.

One day, each of us will stand before God's throne.

We can approach God with confidence because of Christ.

Christ took our sin; we received His righteousness before God.

Christ's sacrifice is the only secure place where we can lean.

Go to God

Turn to the "Go to God" Session 3 on page 180 in the back of the workbook.

Discussion Questions

Spend some time with the following questions. Don't rush to get through each one. Use these questions in the way that best serves your group. Instead of going in order, you can choose to discuss the questions that are most relevant and interesting to you.

1. What stood out to you from the video—did any particular statement or Scripture spark some new insight in you?

2. Megan spoke in the video about Jesus' resume. There are many passages of Scripture that tell us what He is like. For now, find **Philippians 2:6–11** and read it aloud. Based on the passage, name a few qualities Christ has in abundance.

3. Have you heard anyone—yourself included—use the phrase, "I'm just trying to figure it out" recently? What is your reaction to Megan's translation of that phrase: "I'm just trying to control my life"?

4. What hidden beliefs drive us to moralism—that is, trying to grow ourselves by ourselves?

5. How does Megan's imagining of our conversation with God before His throne relate to the greatest commandment (Matthew 22:37)?

6. Why can we approach God's throne with confidence? Look up **Hebrews 4:13–16** and **2 Corinthians 5:21**. Use phrases from the Scriptures to answer.

7. The scene Megan described in God's throne room, that conversation with God, is a description of God's judgement. What kinds of emotions have you associated with "judgment" in the past? Did any of the Scripture Megan used in her teaching help you make new and different associations?

Closing

LEADER: After the discussion time ends, read this closing question, answering it yourself before asking anyone else to answer.

Who are you leaning on—Christ? Yourself? Someone else?

LEADER: Point out the pages of the Personal Study—pages 62–81 for this week.

The personal study this week includes five guided days of prayer and Scripture. Take some time to go through the "Go to God" exercise Megan described at the end of the video if you haven't already.

When and where is the next meeting?_____

Write down the names of your group members so you can pray for them by name throughout the week.

All God's People Said . . .

LEADER: End the time in prayer. Pray or invite someone else to pray—the prayer below is optional.

In You, Father, we are fully known and fully loved. Help us to believe this truth and come before You with confidence, both now and when our earthly lives are over. Instead of leaning on ourselves, we want to lean on You and Your infinite understanding and wisdom. *Amen*

Lean Not on Your Own Understanding

Note from Megan

It's week three.

Are you feeling any more relaxed?

Maybe?

Well. You've got time. And He's got you. He's the only one that you can really lean on.

This week, we're going to read the truth of the Gospel—He took your sins, and He gives you His righteousness. We can come before Him with confidence, fully justified, His dear and beloved children. We're going to keep talking about it. Both because it's good and because sometimes we need to hear the truth in a couple different ways before it starts to sink in.

If you're anything like me, you tend to forget that He's got it all figured out.

And then you keep trying to figure it out yourself.

But trying to figure everything out by yourself is exhausting and impossible. It's a terrible burden to carry.

2 Corinthians 5:21 says "God made him who had no sin to be sin for us, so that in him we might become the righteousness of God."

This, right here, is how we can become relaxed: We can stop trying to figure it all out on our own. This approach doesn't make sense to us from an intuitive standpoint, but that's exactly why we need the admonition to *lean not on our own understanding*. **In trust, we have to step outside of what made sense to us before. We have to lean somewhere else—somewhere stable.** This week, at least once, I hope you take the opportunity to Go to God and seriously think about who you are leaning on (Session 3 "Go to God," page 180). You can also keep tracking that you're going to him, every single day. This is not about behavior management—this is about being honest. And watching the ways that He's growing you.

Here's a reminder. The experience of this study could look like any of these:

1. Go to God each morning and do one personal study day right then, too.
2. Go to God each morning, do a personal study later in the day.
3. Go to God each morning, complete personal study days in larger chunks during quiet spots throughout the week.

Think through what will work best for you before you dive in—but remember, you can relax. You can switch up your plan.

Meghan Fate Nbark

day 1
Lean Not on Your Own Understanding

Today is _____

GO TO GOD DAILY PRAYER (p. 180) ☐

Review

We love *knowing* things. Having the right answer feels good to us. We can get obsessive about what's going to happen to us in the future, too. We like thinking that we know what's going to happen next. And we can get bent out of shape if our expectations aren't met—in other words, if we actually didn't know what was going to happen. "Knowing"—or thinking we know—gives us this impression of control over our lives. Really—what could be better than knowing what's next?

I think there's something better.

And I think you probably think so, too.

We're not supposed to lean on our own understanding. There's something that fulfills us more than straight "knowledge" ever could. Here's a few paragraphs from *Relaxed* to help us explore this.

Read (*Relaxed*, pp. 61–62)

My husband, Randy, was an emergency room (ER) nurse.

The ER is a messy place. Sometimes the processes, sometimes the people, always the situations and problems. Randy witnessed all sorts of messes in that place: broken bones, weird rashes, family dysfunction, the effects of self-neglect, strokes, accidents, the aftermath of bad choices, and many other tragic reasons behind an ER visit. I mean you name it, he probably saw it. It was a mess, but at least the people were in the right place.

In recent years, Randy noticed a decline in people's mental health. One time he shared with me his first response to overwhelmed, anxious patients.

He said he'd stare directly into their eyes. When he had their full attention, he would calmly yet urgently say, "Hi! My name is Randy Marshman. I'm a staff nurse at this ER. There are a lot of things you can do and a lot of things you can't. Here's one thing you can do: listen to my voice! Why? Because I'm really good at my job."

My husband was typically more of a reserved, behind-the-scenes, I-don't-need-attention-for-my-birthday type of guy, so him demanding attention by declaring his competence felt surprising. I remember asking him, "You'd actually say that? That you're good at your job?"

"Of course." He gave me the same stern look he would give to his patients. I realized I was getting to witness firsthand his trust-building tone as he went on. "Then I'd tell them, 'Listen to my voice,' and say it again. 'I'm really good at my job.'"

I smiled as the explanation continued. He was getting people to focus on something other than understanding. There was a lot going on that they couldn't understand: the unknowns of their future, the regrets they couldn't get over, the trials they were facing, the fear and drama of broken people, the sin within themselves, everything. They needed external confidence from someone who understood something about what was happening.

Randy gave them what they needed. He gave them confidence that someone understood and made up for their lack of understanding. . . . He didn't give them greater understanding; he just gave them someone to trust. He gave them his words, his voice, his commands, and his steps for getting somewhere helpful. His voice directed them to the things they could control, subconsciously getting them not to focus on the rest of life. He'd get them to breathe slowly. He'd ask simple questions they already knew the answers to, like "What is your birthday?" or "What is your name?" or "Who did you vote for?" At least they'd smile.

Within ninety seconds, their heart rate had slowed down, their physical body relaxed, and they released their need to figure everything out—at least for the next few minutes. Did they suddenly understand all the details of what was happening to them? I don't think so. I don't think they would have been able to relax if they had.

So much of the time, I think I want understanding. I go so far as to demand knowledge from God. "God, why? Why did it have to happen like this?" But when I think about it clearly, I realize that I don't want to understand. I want something better than understanding. I want to be able to relax. I want peace. I want God's peace. God's peace is not just *bigger* than our understanding. Having God's peace is *better* than understanding. And God gives us His peace the same way Randy gave it to his patients, by giving us someone to trust.

We don't have the capacity to understand everything. Not only that, trusting in God is better than understanding. When we're leaning on His understanding, we can relax. When we're leaning on our own understanding, we're going to run around frantically trying to figure out everything on our own.

What we need the most is **not** understanding. What we need is someone to trust. Someone who is reeeeeeally good at their job. But we can get really confused about what our job is and what God's job is.

Look up and read the Scriptures listed below. Write specific phrases from the verses under "My Job" on the left side and "God's Job" on the right.

Feel free to add phrases from other verses to the chart.

Philippians 2:13; Hebrews 4:13–16; 2 Corinthians 5:21

MY JOB	GOD'S JOB
Example: "receive mercy," (Hebrews 4:16)	Example: "fulfill his good purpose," (Philippians 2:13)

Prayer Prompt

Write a prayer to God, thanking Him for being good at His job.

day 2
Lean Not on Your Own Understanding

Today is_____

GO TO GOD DAILY PRAYER (p. 180) ☐

Read His Word

During the group session, I described the throne room of God. Let's read the verses together. Turn to and read **Isaiah 6:1–4**—they're wild. In the box, draw what's described. *Note: This does not have to be an artistic rendering. This is just us getting a better idea of what Isaiah saw in his incredible vision. You can also turn to Revelation 4 and add details from John's vision, too.*

Read the next four verses: **Isaiah 6:5–8**. Name a few different emotions Isaiah may have experienced while he was before God's throne.

Write out **Isaiah 6:6–7**.

Define "double imputation" in your own words. You can flip back to the group session to check your notes or look up **2 Corinthians 5:21**.

Even though this passage from Isaiah is in the Old Testament, and Christ's death on the cross doesn't take place until hundreds of years later, the scene in the passage hinges on the idea that we are not righteous. Something must happen to us before we can stand before God.

Definition: Atonement

reparation for offense or injury; the reconciliation of God and humankind through the sacrificial death of Jesus Christ

What did God **take away** from Isaiah? (Hint: Read what Isaiah says in **Isaiah 6:5**.)

What did God **give** to Isaiah? (Hint: Read what Isaiah says in **Isaiah 6:8**.)

How did atonement change Isaiah—how does he live differently after he's been justified? (Hint: Keep looking at Isaiah's dialogue in **Isaiah 6:5, 8**— what words would you use to describe his attitude in these verses?)

Prayer Prompt

Write out a prayer of praise, using some of the lines from **Isaiah 6:3** and **Revelation 4:8, 11**.

day 3
Lean Not on Your Own Understanding

Today is_____

GO TO GOD DAILY PRAYER (p. 180) ☐

The Go to God exercise is on page 180. You can keep checking off the days that you prayed.

More from His Word

On Day 2, we entered the throne room with Isaiah and John. Today, we're going to read Hebrews 4. It reveals something about the heart of the One on the Throne—and the heart He wants us to have as we approach Him. (Hint: He wants us to be confident, not hesitant—imagine strolling up to Him without any anxiety or dread. Just . . . *relaxed.*)

There's so much in this chapter. You don't have to "get" everything in one read. We can't do that with any part of His word, anyway. Open your Bible to **Hebrews 4**. It might help to read verses **13–16** *first*, and read through the whole chapter, just to remember where we're going. When you read the chapter beginning to end, underline the word **rest** every time you see it.

"Therefore, since the promise of entering his
_____ still stands, let us be careful that none
of you be found to have fallen short of it."

HEBREWS 4:1

The author of this passage touches on several different time periods: Creation. The nation of Israel. The "present," which was just after Jesus' life, death, and resurrection. In each of these ages, people resisted God's offer of rest. Instead, they tried to figure things out on their own. Turn to the following passages and find a few examples of "trying to figure it out."

Genesis 3:1–15

Exodus 17

Matthew 26:47–75

Can you think of any other stories from Scripture of people "trying to figure it out" without God?

"I'm just trying to figure it out," is a lot like saying, "I'm just trying to control my life." We resist God's rest. We don't want to relax. Why? Because we want control over the results.

Find **Hebrews 4:11** and write it out below.

Based on the Scriptures you read today, what does "rest" mean? How does it relate to being "relaxed"?

Prayer Prompt

Remembering that Jesus is able to empathize with your weakness, write a prayer to Him telling Him why it is difficult for you to enter into His rest.

day 4

Lean Not on Your Own Understanding

Today is _____

GO TO GOD DAILY PRAYER (p. 180) ☐

Nothing Hidden

Look up **Luke 12:2–3** and write the verses here.

What are some of the things you've hidden, the things that came up in your mind when you wrote out those verses? Write eight to ten of them in the chart on the left side under "My Resume".

MY RESUME	CHRIST'S RESUME
(example: refusal to forgive)	

Look up the following verses that describe some of the qualities and actions of God. One at a time, add the quality to the list under "Christ's resume." As you add each quality, cross off one of those "hidden things" on your resume.

1 John 5	**Jeremiah 10:6**	**Hebrews 4:15**	**Rich Young Ruler**
1 Corinthians 13:4–7	**Psalm 108:4**	**Romans 7:25**	

Finally, cross off "My resume."

Double imputation—He takes our sins; we get His righteousness. With all the "figuring out" we could have fit into an entire lifetime; we could never have come up with a resume like that. That's only through His mercy. That's only through His grace. The One on the throne is holding out His hand to us, still inviting us into His rest.

Prayer Prompt

Imagine yourself before God's throne, holding the resume that remains . . . and relax. Offer Him a prayer thanking Him for inviting you into His rest.

day 5
Lean Not on Your Own Understanding

Today is_____

GO TO GOD DAILY PRAYER (p. 180) ☐

Reflect and Relax

Did you gain any insight about whose understanding you usually lean on?

How would you define "double imputation" and "atonement"?

double imputation: _____

atonement: _____

Does contemplating these concepts help you feel more relaxed, especially when thinking about the moment that you'll stand before God? Why or why not?

In what ways have you felt yourself becoming more relaxed?

Can you recall a moment from this past week when you chose to lean into that relaxed life with Jesus instead of grasping for control? Describe that moment here. You can do this in any way you want—you can draw a picture, or make a list, or write down a few words you felt God gave to you.

If not, why do you think that is?

Write a Scripture from one of the personal study days that was significant to you on a sticky note. Put it somewhere you'll see it consistently over the next few weeks (the dash of your car, bathroom mirror, the fridge, etc.).

Looking Ahead

Something to start thinking about for the next group session: Consider a few different expressions of grief. How have you seen someone grieve a loss well? Have you known anyone who refused to grieve?

What's a question that came up in your days of personal study you'd want to ask the rest of the group?

Take a moment to pray for the next group meeting and the members of your group.

relaxed

session 4
Submit to Him in Grief and Mistakes

"The LORD *is close to the brokenhearted and saves those who are crushed in spirit."*

PSALM 34:18

Start Here

> **LEADER:** Pray before you open your study time together, sharing whatever is on your heart with God. Invite others to pray, too.

Tracking Trust

> **ALL:** Flip to the back of your guide, page 173, and record your response to the prompt. As a group, begin each week together reflecting on the transformation you see through your responses on these pages.

In the past few weeks, has your general idea of what God wants from you changed at all? Does that thing you're trying to trust Him with look any different in light of that?

If you're ready, share with the group.

Definitions

Acknowledge
To recognize the rights, authority, or status of; To disclose knowledge of or agreement with; To express gratitude or obligation for; To recognize as genuine or valid

Submit
To yield to governance or authority; To present or propose to another for review, consideration, or decision; To put forward as an opinion or contention

Watch Video

Scripture Covered in This Teaching

Proverbs 3:5–6; 1 Corinthians 15:23; 1 Thessalonians 4;
Romans 8; Psalm 34:18; John 11:35; Isaiah 53:3; Psalm 51

> **LEADER:** Before starting the video, read the following aloud.

There's not going to be a test on any of this. You don't have to write something after each point. Use the margins if you need them. Feel free to pull out your own journal, or to just sit and listen—whatever helps you engage.

Grief and mistakes indicate that things are not what they should be.

The right response to loss is grief.

The pain of grief is an expression of hope that one day, things will be put right.

We try to hide our mistakes from God so we don't have to submit them to Him.

We have to know where the sickness is in order to heal.

To confess is to tell God that we're not as we should be; He already knows our hearts.

Go to God

Turn to the "Go to God" Session 4 on page 181 in the back of the workbook.

Discussion Questions

Spend some time with the following questions. Don't rush to get through each one. Use these questions in the way that best serves your group. Instead of going in order, you can choose to discuss the questions that are most relevant and interesting to you.

1. What stood out to you from the video—any statement or Scripture that you made sure to write down in your notes?

2. What's the underlying similarity between grief and mistakes that Megan talked about in her teaching? Put another way, what does the existence of grief and mistakes indicate about our world?

3. Turn to **1 Thessalonians 4:13–18** and read these verses aloud. How does the rest of mankind grieve? Why is the grief of Christians different?

4. When we're grieving, we often ask questions like, "Where is God?" Based on Megan's perspective in today's teaching and the story of Lazarus and his sisters in John 11, how can we approach that question with hope?

5. The actions of grieving our losses and confessing our sins are necessary "movements" so we don't get stuck in a stage of grief or a particular sin. Have you experienced the liberation I taught about in either of these areas—grief or mistakes? What was that like for you?

Closing

LEADER: After the discussion time ends, read this closing question, and ask volunteers to share their responses and briefly review what comes next.

Take a moment to think of something happening in your life that indicates the world is not as it should be. Maybe it's something you're grieving, maybe it's a mistake that you've made. Maybe it's a little of both. Write it below.

The personal study this week includes five guided days of prayer and Scripture. Take some time to repeat the "Go to God" exercise Megan described at the end of the video if you haven't already.

When and where is the next meeting?_____

Write down the names of your group members so you can pray for them by name throughout the week.

All God's People Said . . .

> **LEADER:** End the time in prayer. Pray or invite someone else to pray—the prayer below is optional.

Father, sometimes we cling to the things in our life that are not as they should be. We struggle to give them over to You, even though You are the one who can bring good out of anything— even our grief and our mistakes. We want to give everything over to You, God. *Amen*

session 4
Submit to Him in Grief and Mistakes

Note from Megan

Oh, friend.

You know that the world is not as it should be. I don't know what you're grieving, but I know that you have grieved—and that you will again. I mentioned already that the verse handed to me, more than any other verse, in the first months after Randy died was:

> The Lord is close to the brokenhearted
> and saves those who are crushed in spirit.
>
> PSALM 34:18

Let those lines of Scripture go deep this week.

We've all been brokenhearted, crushed in spirit, riddled with grief, undone by our own mistakes . . . in short, we've all been a mess. And, once again, Scripture is pointing at exactly what we need: we need the closeness of the Lord. We need Him to save us.

So, this week, let's submit that discord we see in the world and feel in our hearts—whatever its source—to the Author of life, and let Him work on it.

Here's a reminder.

Go to God each morning and make time for your personal study. It's worth it.

Take time with the sessions that you need more time with. God wants to know all you are thinking of, struggling in, wading through, wondering. He's with you in the pain.

Megan Fate Marshman

day 1
Submit to Him in Grief and Mistakes

Today is _____

GO TO GOD DAILY PRAYER (p. 181) ☐

Review

I bet this week's group session reminded you of a few things that you don't love thinking about. Maybe a few things that you didn't really want to think about. But "relax" does not mean "ignore." So, as we're thinking about our "ways," I want to encourage you to just let it all roll in here. There's nothing He doesn't want you to bring to Him. After all, the Proverb does say, "In **all** your ways, submit to Him . . ."

Submitting our grief and our mistakes to God means seeing where He is in them and then letting Him lead us to hope. This doesn't mean glossing over the pain. In fact, hope and pain have a lot of crossover. I wrote about this in *Relaxed*.

Read (*Relaxed*, pp. 98–100)

Grief and hope are God's tools for living in a fallen, broken world. Some Christians suppress grief because they think it isn't an expression of hope, but it is. It's not supposed to be this way. Grief inherently expresses the hope that things are supposed to be different. As Tim Keller is often attributed with having said, "The opposite of joy is not sadness, it's hopelessness." If we had no hope, we'd feel the dullness of apathy instead of the sharp pangs of grief.

> But, out of hope, we can question His timing.
>
> We can get angry with His ways.
>
> We can even fling ourselves to the ground.
>
> Hope compels us to ask God audacious questions in anger and desperation, questions like "God, how long?" And God, in His mercy, moves with us through these feelings. We don't have to hide any way that we grieve from God; we can submit all our ways to Him. Our confused ways, sad ways, irrational ways, and angry ways.
>
> We trust the promise that we won't have to wait forever.
>
> Sin and death are not forever because Jesus is coming back. In Revelation 21:1–5, John describes his incredible vision of heaven and earth coming together. This isn't just a happy ending—this is God's long-fought victory. But for our suffering in this life, this passage wouldn't carry the same weight or meaning. That's why our grief is necessary. It allows us to feel the weight of our sin and rebellion as the price for walking away from God. It acknowledges the important truth that the only solution to both our grief and our rebellion is God.
>
> That's why God didn't just move from the garden of Eden into paradise. We needed this.

But John describes what's going to happen next:

Then I saw "a new heaven and a new earth," for the first heaven and the first earth had passed away, and there was no longer any sea. I saw the Holy City, the new Jerusalem, coming down out of heaven from God, prepared as a bride beautifully dressed for her husband. And I heard a loud voice from the throne saying, "Look! God's dwelling place is now among the people, and he will dwell with them. They will be his people, and God himself will be with them and be their God. 'He will wipe every tear from their eyes. There will be no more death' or mourning or crying or pain, for the old order of things has passed away."

He who was seated on the throne said, "I am making everything new!"

Grief is evidence of this reality: we are still separated from our God. It was never meant to be that way. And yes, friend, that separation hurts to the core. Death is one of the sharpest reminders that the separation will not last forever. His dwelling place—His home—will be with us. Death will be nothing but a memory.

The pain of grief is rooted in the wrongness of death itself—*it was never supposed to be like this*. And God is grieving that reality, too. When we make that connection, we realize that He is in our grief with us. No, it was never supposed to be like this . . .

We're all in it—this mess of grief and mistakes. What does that look like for you and for the people you love? You don't have to tell the whole story. Just a word or phrase will do. List some examples of grief and mistakes on the left side of the chart under "Pain."

Follow the arrow across the chart, jot down a note about how some of the instances of pain you listed on the left side have led to hope.

And if you can't think of anything to write on that right side, if the pain is just too deep or too fresh, take heart. *It won't always be like this.*

PAIN	HOPE
(example: loss of a job)	

Last session we imagined ourselves before God's heavenly throne. And today we read some words God speaks from that throne of power, grace, and mercy.

Read **Revelation 21:5** in your own Bible. Write the verse here.

Prayer Prompt

Imagine God speaking those words from **Revelation 21:5** over you and your pain. Write a prayer in response.

day 2
Submit to Him in Grief and Mistakes

Today is_____

GO TO GOD DAILY PRAYER (p. 181) ☐

Grief

We need other stories of grief in order to understand our own and to learn how to grieve well. John 11 tells that famous story of the death and resurrection of Lazarus. Read **John 11:1–44** in your own Bible. As you read it, list some of the words and actions of Mary, Martha, and Jesus in the chart. You can also take note of anything that stands out to you about the story.

MARY	MARTHA	JESUS
(example: sent word to Jesus)	(example: sent word to Jesus)	(example: returned to Judea)

Name a few examples of each of these people—Mary, Martha, and Jesus—"moving" within their experience of grief instead of getting "stuck." What did they *do* with their pain? What did they *say*?

Mary: (example: weeping)

Martha:

Jesus:

Reread **John 11:40–41**. What does Jesus say to Martha? Write it here.

What does Jesus thank His Father for? _____

Now, read **Romans 8:18–21**. How does the story of Lazarus connect with what Paul teaches in these verses?

Martha, Mary, and Jesus all let God in on their pain. They didn't shut Him out. And, in that way, they submitted their grief—the weeping, the groaning, the spoken disappointment—to Him. We have to let God in on our pain in order to grieve well. Sometimes, we have to work through the notion that we're burdening Him with something. Or maybe we're actively trying to keep Him out. Or maybe we're stuck in our anger. Remember, God wants to hear it all. He can handle it all.

And He will use it to reveal Himself and His glory.

Prayer Prompt

Write a prayer, asking God to show you if you're stuck anywhere in your grief. If you need to, borrow the words of Mary and Martha: "Lord, if you had been here . . ."

day 3
Submit to Him in Grief and Mistakes

Today is _____

GO TO GOD DAILY PRAYER (p. 181) ☐

Mistakes

On Day 2, we read through the story of Lazarus and saw Jesus encounter people who were grieving. And He grieved with them—John's words tell us *twice* that Jesus was "deeply moved" (John 11:33, 38).

The idea of a God who grieves with us is so consoling and so good. But what about the other part of this session? What about our mistakes? Jesus never made a mistake. So, approaching Him with our mistakes can feel daunting. But let's find out how Jesus talks to people who have made mistakes.

First, turn in your Bible and read **John 4:13–26**. If you want, you can read the whole chapter for the context. This is such a deep, rich passage of Scripture. Today, we're focusing in on particular parts of the text to really draw out how Jesus handles our mistakes. Jesus is in the middle of

a conversation with a woman, and they are by the well outside of her town. Not only are Jesus and this woman on different "sides" (she's a Samaritan, He's a Jew), she's an outcast from her own people. But Jesus started talking to her, anyway.

What do you observe in this passage about Jesus and this woman? How would you describe the way He talks to her and treats her? Circle the words that describe Jesus in this encounter.

dismissive	open	curious	bored	sad
angry	gentle	afraid	thoughtful	overwhelmed

Write out any other observations you have about what Jesus did and said.

Write out the exchange Jesus has with this woman in **John 4:16–18**.

Who is specific? Who shies away from the details?

Write a sentence that describes how Jesus approached this woman's mistakes.

Now, read **John 4:27–30 and 39–41**. Write out verse 39.

How was the woman changed after she talked with Jesus about her mistakes? Fill in the chart below.

BEFORE	AFTER
(example: alone)	(example: among others)

Prayer Prompt

Remember how Jesus talked and listened to the Samaritan woman—He wants to do the same for you. Write a prayer asking Him for the kind of courage showed by the Samaritan woman—courage that leads others to Him.

day 4
Submit to Him in Grief and Mistakes

Today is _____

GO TO GOD DAILY PRAYER (p. 181) ☐

Submit to Him

This session, we've talked about how grief and mistakes are both indicators that things are not as they should be. But God can use them for good. We read that God's glory was revealed through Lazarus' resurrection (John 11:40) and many people came to believe in Him through the Samaritan woman's testimony (John 4:39).

When grief and mistakes are submitted to Him, He shows up in a big way. But how do we practically submit those things to Him? In both cases, we go before Him in prayer. But here's the difference: With grief, it's hard to know what to say. With mistakes, it's hard to get ourselves to just . . . say it.

Neither of these things are easy, but we can look to God's word for help. Let's start with **grief**.

Look up **Romans 8:26–27** and write it below.

Who is praying for us? _____

We can get kind of picky about what qualifies as "prayer." Being with Him in silence *is prayer*. And when we're talking about grief, sometimes there are no words. I want you to turn to the "Trust Tracker" on page 173. What is it you're trying to trust God with during this study?

Write whatever's in your "Trust Tracker" below in this box.

I don't know—but I'd be willing to guess—that there's some grief surrounding the thing you're trying to trust God with. Maybe you don't even know how to pray about it. Would it be easier if you didn't have to say anything at all?

You don't.

Maybe it's time to let Someone else intercede *for* you.

Now, find a timer, or just glance at a nearby clock. Set it for however long you think you can take—five minutes, ten minutes, one minute. And sit in silence while the Spirit prays on your behalf.

But what about **mistakes**? Well, it's almost the opposite. You need to get specific.

Again, let's turn to Scripture. Open your Bible to **Psalm 51**. The specificity is right there in the subtitle. David's mistake is described in plain language without any excuses or justifications.

Do we do the same thing when we're talking to God about our mistakes?

There's a temptation to go on and on about *why* we did what we did—but God already knows everything. We need to admit that we were wrong and ask for forgiveness.

Now, turn to **1 John 1:9** and write it here.

Turn again to **Psalm 51** and read it slowly. Take the chance to get specific. Ask the Spirit to work in your heart.

What are some "subtitles" that you could give to Psalm 51—some sins you need to confess in His presence? You can't surprise Him. Ask Him to reveal your heart.

Write out **Psalm 51:13**.

He is faithful and just, and will forgive you and purify you.

Take a moment to rest in His forgiveness.

Prayer Prompt

Shame has power in darkness. Ask God to bring to mind the name of a trusted friend and consider sharing your confession with them.

day 5
Submit to Him in Grief and Mistakes

Today is _____

GO TO GOD DAILY PRAYER (p. 181) ☐

Reflect and Relax

Describe a few connections between grief, mistakes, and hope that you
discovered during your time studying His word and sitting with Him in prayer.

In grief, remember to let the Spirit intercede for you—in mistakes, get specific
in your prayer. Did these approaches help you relax? Why or why not?

In what ways have you felt yourself becoming more relaxed?

Can you recall a moment from this past week when you chose to lean into that relaxed life with Jesus instead of grasping for control? Describe that moment here. You can do this in any way you want—you can draw a picture, or make a list, or write down a few words you felt God gave to you.

Write a Scripture from one of the personal study days that was significant to you on a sticky note. Put it somewhere you'll see it consistently over the next few weeks (the dash of your car, bathroom mirror, the fridge, etc.).

Looking Ahead

Something to start thinking about for the next group session: We're going to start talking about risk. Name a few things that you would call "small risks" and a few things you would call "big risks."

Small risks:

Big risks:

Do you think relationships are risky? Why or why not?

What's a question that came up in your days of personal study you'd want to ask the rest of the group?

Take a moment to pray for the next group meeting and the members of your group.

session 5
Submit to Him in Risk and Friendships

"Greater love has no one than this: that one lay down one's life for one's friends."

JOHN 15:13

Start Here

> **LEADER:** Pray before you open your study time together, sharing whatever is on your heart with God. Invite others to pray, too.

Tracking Trust

> **ALL:** Flip to the back of your guide, page 173, and record your response to the prompt. As a group, begin each week together reflecting on the transformation you see through your responses on these pages.

What is it that you're trying to trust God with? Name a few of the people associated with it. Record their names in the "Tracking Trust" section at the back of the workbook page 173.

Definition: Risk

possibility of loss or injury; someone or something that creates or suggests a hazard

in Megan terms:
the bridge between where you are and where you long to be

Watch Video

Scripture Covered in This Teaching

Proverbs 3:5–6; Genesis 1:26–28, 2:18; Ephesians 3:14–21; John 15:15; Romans 12; John 17; Matthew 7:12; Acts 20:35

> **LEADER:** Before starting the video, read the following aloud.

There's not going to be a test on any of this. You don't have to write something after each point. Use the margins if you need them. Feel free to pull out your own journal, or to just sit and listen—whatever helps you engage.

God made us in His image—our need for community started when we were created.

We can idolize perfect friendships.

Jesus is the perfect friend—through His love, we love others.

Risk leads us to God, because when we risk, we need Him.

We can't know ourselves unless we're known by others.

Jesus' advice on friendship: Be the friend you want to have.

Go to God

Turn to the "Go to God" Session 5 on page 182 in the back of the workbook.

Discussion Questions

Spend some time with the following questions. Don't rush to get through each one. Use these questions in the way that best serves your group. Instead of going in order, you can choose to discuss the questions that are most relevant and interesting to you.

1. What stood out to you from the video—any statement or Scripture that you made sure to write down in your notes?

2. Why does taking risks lead us closer to God—what does this look like in daily life?

3. Turn to **John 15:9–17**. Before you read the passage, remember this idea from the teaching: This passage is about seeing Jesus as the greatest friend. Read the passage together. How does Jesus offer us strength and hope about our relationships through these words?

4. Why can't it be just "Me and Jesus"? What are we missing out on if we think that way?

5. Often, God asks us to take small risks throughout our daily lives. What is difficult about this kind of risk-taking?

6. How does hiding our flaws impact our ability to engage in friendships? Name a few ways a person might "hide."

7. Draw the "Johari window" that Megan taught about in the video, circling the portion of a person that only God can know. How does reaching out to Christian friends help us to know ourselves?

8. What does "a nudge" or "a prompting" from the Holy Spirit look like in your life? If you want, share briefly—what has the Holy Spirit been prompting you to do?

Closing

LEADER: After the discussion time ends, read this closing question, and ask volunteers to share their responses and briefly review what comes next.

What is helpful for a person who is in your "season"?

LEADER: Point out the pages of the Personal Study—pages 115–137 for this week.

The personal study this week includes five guided days of prayer and Scripture.

When and where is the next meeting?_____

To Him, for Each Other

Write down the names of your group members so you can pray for them by name throughout the week.

All God's People Said . . .

LEADER: End the time in prayer. Pray or invite someone else to pray—the prayer below is optional.

You created us for relationships, Father. We want to know ourselves and You more fully through the relationships You've given to us. Help us draw nearer to our perfect friend, Jesus, and to live out the love that He gives to us in abundance. *Amen*

session 5
Submit to Him in Risk and Friendships

Note from Megan

Here's one of the many remarkable things about Proverbs 3:5–6: The proverb **approaches us in the right order.**

Think about it—skipping to "in all your ways submit to him" would be pretty daunting, wouldn't it? I mean, why would we do that? We like our ways. Without taking the other steps in the verse first, autonomy seems to make the most sense for the "ways" of our life—after all, they're "our" ways!

But think about where we've come from.

"Trust in the LORD . . ."

We place our trust elsewhere—in Him, not in ourselves.

"With all your heart . . ."

Even with the unbelieving parts of our heart—we offer those to Him, too.

"Lean not on your own understanding . . ."

Okay. If we're working with the content of the verse so far, **we are outside of the bounds of autonomy.** We've come to a new place. And in that new place . . . God can do new things in us.

"In all your ways, submit to him."

Seven words, but it covers pretty much everything, doesn't it? **All our ways, all to Him.**

And He's going to take us where we've never been before.

Do you like taking risks? Well, maybe you do—but most of us don't. And, for all of us, there are types of risk that we don't like taking. For example, maybe you'd go cliff jumping in an instant, but getting back in touch with your brother? That sounds hard. Too hard.

Relationships are risky. But, if we're already forgoing autonomy, God's going to guide these relationships. That's not to say it will be easy. But it will be worth it. To be known and loved is everything that we are longing for—it's a taste of Heaven—but it feels risky to reach out and ask for it, doesn't it?

It does for me, too. May God help both of us this week.

Continue to pray every day. You can track how that's going in the week 5 "Go to God" section (page 182). That "Go to God" daily prayer is like a mini risk experiment, too.

Here's a reminder. The experience of this study could look like any of these:

1. Go to God each morning and do one personal study day right then, too.
2. Go to God each morning, do a personal study later in the day.
3. Go to God each morning, complete personal study days in larger chunks during quiet spots throughout the week.

Think through what will work best for you before you dive in—but remember, you can relax. You can switch up your plan. You can try something new. Sometimes we have to try a hundred different ways before we find one that fits.

Even if all that trying feels . . . you know what I'm gonna say . . . **risky.**

Megan Fate Marshman

day 1
Submit to Him in Risk and Friendships

Today is _____

GO TO GOD DAILY PRAYER (p. 182) ☐

What happens when you risk? I wrote about this in *Relaxed*.

Read *(Relaxed*, pp. 123, 128–129)

Here's what my risk experiment looked like. Each day I tried to think about what Jesus would do if He were me. Whenever I felt the little nudge from the Holy Spirit to remember someone or do something, I would do my best to catch that moment (by the grace of God) and say yes to it . . .

Throughout my risk experiment, I was waiting for the epic moments of failure. But the surprise was that risking for God became easier over time. Perhaps this was because God answered each risk like He answered the great faith risks in the Bible: with His presence. When Moses asked, "Who am I that I should go to Pharoah and bring the Israelites out of Egypt?" God answered, "I will be with you" (Ex. 3:11–12). I was anticipating some big failures, and to my surprise, I wasn't rejected once. Why? Because each risky moment was simply me offering love. To pray for someone. To encourage someone. To get to know a cashier. To look an unhoused

woman in the eyes and ask what she needed more than anything. To my surprise, her answer wasn't "I need money." The lady told me she needed a job.

While I don't know the end of the story for the lady without a home, I did make some calls. Our conversation started after I saw her digging through my trash for cans in my front yard. At first, I was uncomfortable. But within thirty minutes, we were hugging and crying in the rain. I knew that talking to her was my next Spirit-led risk. It felt like a strange Hallmark movie. I got on the phone with my sister who could set up a few job interviews. I described the woman as a hard worker, willing to do whatever it would take to make ends meet.

You know, I feel a bit uncomfortable sharing stories where I'm a hero who does something right. The truth is the real hero is in me (yes, I'm talking about Jesus). He prompts me to do some pretty risky things. Mostly, I say no. Every once in a while, like in the Hallmark moment with the lady by the trash, I go with it.

Love didn't fail.

People didn't reject love.

I know that sometimes they do. I like how Jim McMahon put it: "Yes, risk-taking is inherently failure-prone. Otherwise, it would be called sure-thing-taking." But I'll tell you, risk is possible because the one we're risking for *is* a sure thing. The risk journey was just as much for me as it was for anyone I was stopping to notice or listen to or pray for.

I wonder if this is what Peter found when he walked on water. Maybe he found his greatest source of strength not while performing the miraculous but in the moment he was sinking and finally reached out his hand to take hold of Christ Himself.

God answers our inadequacy not with affirmation but with His presence. "I will be with you." That's why risk is so powerful and important. When we are out of our depth, we open ourselves (and others) to an encounter with the presence, power, and love of God. We don't look for His presence when we're comfortable. Could it be that constant comfort is a sign of autonomy, of believing the lie that we can do it ourselves? Yikes.

Let's do a risk assessment. Here's what I mean by that—let's assess what kinds of risks you usually take, and what kinds of risks you usually avoid. And let's call a "risk" anything you did or tried even though you didn't know what the result would be. These can be large, once-in-a-lifetime risks, or small, everyday ones.

Write those risks—taken or not taken—in the corresponding places in the chart.

In the third column, fill this space with risks—both long term and short term—that you want to take in the future.

RISKS I'VE TAKEN	RISKS I DIDN'T TAKE	RISKS I WANT TO TAKE

Can you make any connections among the risks you didn't take—are any of them similar to each other, or related to a specific part of your life? Name any patterns you see.

Think about the risks you've taken. Did those risks usually lead to failure—or not? In a few sentences, describe what's happened when you chose to risk.

Let's set up your own risk experiment. If you're anything like me, you have to be pushed out of autonomy and comfort. And taking a risk is a very purposeful way for us to do that. Choose one thing out of your "risks I want to take" list—it's going to have to be one of those smaller risks, though, because I want you to do it . . . right now.

Right now?

Yes. Right now. As soon as you can. If it's possible, before you close out this time of study in prayer.

Send the text. Make the call. Lean over to the person sitting next to you in the coffee shop and introduce yourself.

In the next personal study, we'll talk about how it went.

Prayer Prompt

With a few lines of prayer, submit your risky idea to God and ask Him to lead you where you should go—you can do this. The only things you have to lose are things you've been trying to lose all along, like fear of others, fear of rejection, and the need to people-please.

day 2
Submit to Him in Risk and Friendships

Today is _____

GO TO GOD DAILY PRAYER (p. 182) ☐

Risk Experiment

Before we dive into scripture together, let's talk about your risk experiment.

What risk did you take?

Use the boxes to describe your experience—the box on the left is for what you thought would happen before you took the risk. The box on the right is for what actually happened. You can use words, or pictures, or both—whatever works best for you to tell the story.

WHAT I THOUGHT WOULD HAPPEN	WHAT ACTUALLY HAPPENED

Christians would do well to make risk into a habit. Risks help us step out of our comfort zone and into the "God, let's do this! I need you" zone. And people who live in that zone—the "loving risk" zone—draw other people to Jesus. What do I mean by "loving risks"? I mean risks that require us to draw on our faith in Jesus to act like He would in the day-to-day situations we find ourselves in. Need examples? I'm glad you asked.

SOME EVERYDAY RISKS:

- Ask someone out for coffee.

- Pray for someone on the spot out loud.

- Sign up to volunteer for that thing at church.

- Show up to the church event (and, while you're at it, choose to love someone you don't know well first instead of wondering who you know in the room) when it would feel safer/easier to stay home.

- Ask someone about their relationship with Jesus (oftentimes, asking thoughtful questions communicates love more than being the know-it-all).

Let's turn to Scripture to find out more. During the group session, we talked about Acts 20:35. Paul quotes Jesus, reminding other Christians of this truth: "'It is more blessed to give than to receive.'"

Do you know the rest of the story? Let's find out together. Turn to **Acts 20:17–38**. Paul speaks to the elders of the Ephesian church while he is on his way to Jerusalem. He knows that he won't ever see these people again, so his words to them are that much more powerful because they're his last.

As you read the passage, name a few of the risks that Paul was willing to take and write them in the chart.

PAUL'S RISKS

Why was Paul able to take these risks? (Hint: Look at **Acts 20:24**.)

Using Acts 20:24 as your inspiration, write about the tasks that God has given you and what they are worth to you. With the guidance and strength of the Holy Spirit, what are you willing to risk—and why are you willing to risk it?

Prayer Prompt

Write a prayer asking God to help you do "both/and" when it comes to risks . . . ask Him to help you embrace risks of all types as a way of life, like Paul did AND ask Him to help you recognize when you're tempted towards autonomy, even when you're taking loving risks.

day 3
Submit to Him in Risk and Friendships

Today is _____

GO TO GOD DAILY PRAYER (p. 182) ☐

Friendships

In the following box, I want you to sketch out what you want from your friendships. You can use sentences or single words; you can write out a list or tell a story. If it's helpful to you, connect the ideas with arrows or lines.

If you need some inspiration, look up some of these words on friendship from **Proverbs—16:28; 17:17; 18:24; 27:5–6**.

Great. If you had to distill it down to one sentence based on the ideas you just gathered, what would you say a good friend does?

Turn to **John 15:5**. What does Jesus tell His disciples in this verse?

Now, turn to **Ephesians 3:16–21** in your Bible. Paul writes an incredible description of what it looks like when we remain in Jesus. (Notice how Jesus and Paul are both using plant imagery—I think that's cool. Just me?)

Starting with the phrase "And I pray that you" in the middle of **Ephesians 3:17**, write out Paul's prayer through **Ephesians 3:19**.

According to these verses, what power does Christ's friendship (Him dwelling within us) give to us?

Christ extended His friendship to us, but He was perfectly rooted in the knowledge of *how much His father loved Him*. The people who make the best friends are the people who are already "rooted and established in love" (Ephesians 3:18).

Of course, this doesn't mean you have to hide yourself away until you completely understand how much God loves you, *then* act in friendship. You'll be hiding for a while. But . . . as you offer yourself in friendship, **think about where your strength comes from.**

Just at the beginning of this personal study day, what did you write down when I asked what a good friend does?

Could you do that for someone today? Ask the Holy Spirit to bring someone to mind. Remind yourself of how loved you already are, then make a plan to reach out in friendship.

Prayer Prompt

Write a prayer of praise to Jesus, thanking Him for the greatness and depth of His love. End your prayer by writing out **Ephesians 3:20–21**.

day 4

Submit to Him in Risk and Friendships

Today is _____

GO TO GOD DAILY PRAYER (p. 182) ☐

You can keep tracking the days that you prayed on page 173.

The Perfect Friend, the Biggest Risk

John 15–17 are beautiful chapters of prayer and teaching—these words are what Jesus gives to His disciples just before He gives His life on the cross. What does the greatest Friend say before He gives up His own life?

As we read these words, let's recall that the verses in these chapters are not supposed to be a checklist that tells us about the kind of friend we're supposed to be. It's the cry of Jesus' heart to God, His Father, who He trusted with all His heart. The prayer tells us about the kind of Friend *we already have.*

Let's take a look.

Read **John 15:9–13** and write out **John 15:13**.

How does Jesus' love for others lead Him to risk?

Read **John 16:1–11**. What kind of risks does Jesus say His followers will have to take? Who will help them?

Read **John 17:20–26**. Who does Jesus pray for in these lines?

If you want, read other portions of the chapter. Using the chart, make notes about what that chapter speaks to you about risk, friendship, and Christ's love.

RISK	FRIENDSHIP	CHRIST'S LOVE

Borrowing some phrases from the "High Priestly Prayer," think through what the point of risk is—why did Jesus take risks on our behalf? Should we do the same thing for others? Why?

Prayer Prompt

Thank Jesus for His risk and for His gift of the Holy Spirit.

day 5
Submit to Him in Risk and Friendships

Today is_____

GO TO GOD DAILY PRAYER (p. 182) ☐

Reflect and Relax

Did you gain any insight about whose understanding you usually lean on?

How would you define "risk" in your own words?

Risk: _____

After your study this week, do you feel any more relaxed about the idea of "risk-taking" as a way of life? Why or why not?

Have you felt yourself becoming more relaxed?

Can you describe a moment from this past week when you chose to lean into that relaxed life with Jesus instead of grasping for control? What did that look like? You could also describe a moment when you grasped for control instead—why do you think that happened? Describe that moment here. You can do this in any way you want—you can draw a picture, or make a list, or write down a few words you felt God gave to you:

Write a Scripture from one of the personal study days that was significant to you on a sticky note. Put it somewhere you'll see it consistently over the next few weeks (the dash of your car, bathroom mirror, the fridge, etc.).

Looking Ahead

Something to start thinking about for the next group session: What feelings come up when you hear the word . . . "money"? Explore a few of those now.

What's a question that came up in your days of personal study you'd want to ask the rest of the group?

Take a moment to pray for the next group meeting and the members of your group.

relaxed

session 6

Submit to Him in Money and Trials

"For where your treasure is, there your heart will be also."

MATTHEW 6:21

Start Here

LEADER: Pray before you open your study time together, sharing whatever is on your heart with God. Invite others to pray, too.

**Leader—this week's "Go to God" activity requires sticky notes. Have these ready beforehand—you'll need two different packages of colored sticky notes for each member of the group.

Tracking Trust

ALL: Flip to the back of your guide, page 173, and record your response to the prompt. As a group, begin each week together reflecting on the transformation you see through your responses on these pages.

Does the thing you want to trust God with fall into any (or several) of the ways covered in the study (grief, mistakes, risks, friendships, money, and trials)? Which "way" is it? If you think the thing you're trying to trust God with isn't covered in any of these ways, what "way" is it? (Examples: family, work, anger, future, church)

If you're ready, share with the group.

Definition: Stewardship

the office, duties, and obligations of a steward; the conducting, supervising, or managing of something, especially: the careful and responsible management of something entrusted to one's care

Watch Video

Scripture Covered in This Teaching

Proverbs 3:5–6; Matthew 6:19–25; Psalm 24:1;
James 1:2–4; 2 Corinthians 12:7–10

> **LEADER:** Before starting the video, read the following aloud.
> Have sticky notes ready to give to each group member after
> the "Go to God" video.

There's not going to be a test on any of this. You don't have to write something after each point. Use the margins if you need them. Feel free to pull out your own journal, or to just sit and listen—whatever helps you engage.

The way we use our money reveals our hearts.

Believing we are stewards, and not owners, of God's gifts brings freedom.

God can use our worries to teach us more about Him and more about ourselves.

In trials, we can experience the intensity of joy.

True worship is bringing our whole heart—even our suffering—to God.

God uses our trials to mature us and reveal what we're really placing our trust in.

Go to God

Turn to the "Go to God" Session 6 on page 183 in the back of the workbook.

Discussion Questions

Spend some time with the following questions. Don't rush to get through each one. Use these questions in the way that best serves your group. Instead of going in order, you can choose to discuss the questions that are most relevant and interesting to you.

1. What stood out to you from the video—any statement or Scripture that you made sure to write down in your notes?

2. Why does Jesus talk about money? What is He trying to reveal to us?

3. Read **Matthew 6:19–27** together. Think about a recent experience of worry—how do Jesus' words speak to you in that worry specifically?

4. Megan taught about how difficult it was to surrender her worry about money to God, because she felt like the money was something she had earned. Do you relate to her story? Is there anything else that you feel is yours instead of His? What are some practical ways that we can move from "ownership" to "stewardship"?

5. How can we look at our worry as an opportunity for growth?

6. Read **James 1:2–4** together. Does the teaching you heard today shift your perspective on these verses? If so, how?

7. What potential is there in our trials?

8. Think of a person you know who you would describe as "mature." Two questions. One, do you know of any significant trials they have been through? Two, do they express joy? How?

Closing

LEADER: After the discussion time ends, read this closing question.

Flip back to the Go to God section on page 183.

> How is God growing you and making you mature? What kinds of patterns do you see? If you want to share, share with your group.

LEADER: Point out the pages of the Personal Study—pages 145—163 for this week.

The personal study this week includes five guided days of prayer and Scripture. Take some time to repeat the "Go to God" exercise Megan described at the end of the video if you haven't already.

> When and where is the next meeting?_____
>
> Write down the names of your group members so you can pray for them by name throughout the week.

All God's People Said . . .

Father, we declare our trust in You, even in the midst of worry and trials. We know that You can use anything to make us mature—to make us more like Your Son. The very next time we're worried, help us remember to reach out to You in prayer and open our worry up to You. *Amen*

session 6
Submit to Him in Money and Trials

Note from Megan

Hey.

This week, things got personal. Well, even more personal. And it seems like we're back to where we started. **Our aim is to trust in the Lord with all our hearts, and money and trials reveal our hearts.** No matter how uncomfortable that can be, we need to bring these personal things to God. We need to share them with Him, and we need to find our rest and our hope in Him.

> What do you do when you feel worried?
>
> Do you try to "just stop worrying"? How does that work out for you?
>
> Do you get stuck in loops of worry, repeating the same things over and over to yourself?
>
> Do you beg Him to take your worry away?

This week, we're going to do something different with our worry—we're going to offer it to Him. We're going to look at the worry *with* Him. And we'll let Him lead us into a deeper understanding, His understanding, of what's going on in our hearts. **Because He desperately wants our hearts.**

This is our final personal study time. We'll go deeper into this week's teaching with Scripture, but we'll also take some time to reflect on the weeks of personal study we've already done.

Continue to pray every day. You can track how that's going in the week 6 "Go to God" section (page 183).

Here's a reminder. The experience of this study could look like any of these:

1. Go to God each morning and do one personal study day right then, too.
2. Go to God each morning, do a personal study later in the day.
3. Go to God each morning, complete personal study days in larger chunks during quiet spots throughout the week.

I hope you've discovered a rhythm that you like, because "Going to God" isn't something you should just do for six weeks—it's something you can do for the rest of your life. The practice of turning to Him is a foundational piece of the relaxed life with Him.

And it's something I hope you take with you, no matter what else you learned in these weeks. And on the days when you forget, I hope *the very next thing you do* is Go to God.

"God, I forgot to go to You! Here I am now. Help me remember."

He'll never turn you away.

day 1
Submit to Him in Money and Trials

Today is _____

GO TO GOD DAILY PRAYER (p. 183) ☐

Review

Have you ever noticed that some of the most joyful people are the people who have very little—or the people who have experienced a lot of pain? That doesn't track with our culture's understanding, which is summed up by: "Get stuff! Avoid pain!"

But we know that having a lot of material goods and avoiding pain (which often involves avoiding other people) doesn't guarantee happiness. It doesn't guarantee anything. But man—we often look at money (and pain avoidance) as a solution to our problems. We'll start with money. When did money start to matter in your life? I remember when it started in mine. Here's the story from *Relaxed*.

Read (*Relaxed*, pp. 153–154)

Where your thoughts are is where your heart is, and recently, it has come to my attention that I think about money all the time.

I needed to do some soul searching about this, because this wasn't how I got started in ministry, and "worried about money" is not how I'm going to spend the rest of my life. Have you ever felt the freedom of working for practically nothing? Years ago, I spent six summers working at a Christian camp. The demands on the staff were reasonable considering how epic the environment was (and still is). But we made some less than responsible choices—we overworked, and we stayed up way too late. Once, just for fun, we calculated that we were working fourteen-hour days for $1.31 per hour. But it was so worth it to us. Around this same time, I started taking speaking engagements for $0.00 per hour. One of the first was at an all-nighter; I had the 2:30 a.m. timeslot. Perfect. At a different event, my great reward for my time and my thoughts was a Chick-fil-A coupon for a single chicken sandwich. I would have to pay for the fries! It turned out that the coupon was expired, so I paid for the sandwich too. The point is, I didn't think about money all the time. I wasn't working for money, and I wasn't speaking for the sake of it. If there was any treasure gained, it couldn't be stored on earth.

Then I started doing more and more speaking. Most of the time, the reward I received was a "Thank you, Megan!" or a gas card. I remember receiving my first honorarium. This was in 2008. After I gave an address at my alma mater, someone handed me an envelope and said, "Here's your honorarium." I didn't even know what that word meant. I opened the envelope and found a check for fifty dollars. Wait a minute, I thought, I can get paid money for this?

Are you worried about money? Mark your level of worry on the scale.

1 = Nope, not at all!, 5 = Depends on the day, 10 = Very, very worried.

1	2	3	4	5	6	7	8	9	10

When in your life were you most concerned about money? _____
Where would you have placed yourself on the scale? _____

Tell a short story about the most satisfying work that you've ever done in your life. You can be pretty flexible about what "work" means here—you don't have to talk about a formal "job," but you can!

While you did this work, were you concerned about money? Why or why not?

What does the story you wrote reveal about your heart and what you value? Ask the Holy Spirit to guide you.

Prayer Prompt

God wants your heart—all of it. What did you learn about your heart today? Write a prayer, offering your heart to Him.

day 2
Submit to Him in Money and Trials

Today is _____

GO TO GOD DAILY PRAYER (p. 183) ☐

Money

Let's go back to the Sermon on the Mount again and look closely at what Jesus said about money.

Well, sometimes it helps to know where we're headed. Look up **Matthew 6:25** and write the first half of the verse here. In the NIV translation, it's the first ten words:

Alright. This is where Jesus is taking us—He's telling us not to worry.

With that in mind, let's go back to **Matthew 6:19–21**. I want you to draw what you read about. It doesn't have to be a great drawing—but I want us to pay close attention to this passage, and sometimes it helps if you try using a different part of your brain. (You can do this kind of thing with any passage of Scripture by the way. Draw it out. Read it out loud instead of silently. Summarize what you read to someone else. Alright. Back to where we were!)

Matthew 6:19–21. Read it and draw a picture of what Jesus is saying. For example, I would start by drawing two different storehouses.

Matthew 6:22–23. Read and draw a picture.

Matthew 6:24. Read and draw this verse, too.

If the topic is money, doesn't it kind of feel like the discussion about light—that box in the idle—is a weird tangent?

The first many times I read this passage I was confused about the lamps. But Paul's letter to the Ephesians helped clear things up for me.

Look up **Ephesians 1:18** and write out Paul's prayer.

What happens if the "eyes of your heart" are darkened? Confusion, right? You can't see your heart—the very core of who you are—clearly. You can't make distinctions. If you asked yourself who you were serving, God or money, you might not even know, because things are so dark in there.

But praise God for His mercy. Let's look at the end of Ephesians 1:18—"You, the riches of his glorious inheritance . . ."

Who is Christ's glorious inheritance—that is, His treasure? _____

And, as we know from Matthew 6:21, "For where your treasure is, there your heart will be also."

Here's another remarkable thing about Jesus speaking those words: His heart is with His treasure, too.

That's where we have to go with money, my friend—with realizing that His treasure is *us*.

Prayer Prompt

Write a few lines of prayer asking God to enlighten the eyes of your heart.

day 3
Submit to Him in Money and Trials

Today is _____

GO TO GOD DAILY PRAYER (p. 183) ☐

Trials

Here's what we learned in the group session: Trials have *meaning*. God has not abandoned you to the pain you experience. He will do something with it. Just as the suffering and the trials of God's own Son had purpose, your suffering has *purpose*.

I know that doesn't make it better—not really. I mean, it doesn't mean the pain suddenly disappears.

But I want you to know this: God is with you in those trials, and He is growing you through them.

Let's read what Paul wrote about trials in **2 Corinthians 12:7–10**.

Write out what God says to Paul—the part in quotes.

Let's go back to the timeline you created during the group session. Gather as many of those sticky notes as you can. We're going to do an expanded version of the timeline here.

Grab the remaining sticky notes, using one color for positive moments and one color for negative moments.

Choose a time limit—three, five, or ten minutes. Read through your other notes so you know which moments you've already chosen.

> First, write positive notes for the chosen amount of time.
> Then, write the negative ones for the same amount of time.
> Place them along the timeline in chronological order.

Look over the notes on the timeline. Select several that represent weaknesses or hardships, drawing stars on those notes or marking them as different in some way. Choose between four and eight notes. Near the note, write a sentence about how God showed His power during that moment.

Now, write out **2 Corinthians 12:10**.

How can we have this perspective on weaknesses? Well, it's like Paul wrote—it's for Christ's sake. Our trials can draw us nearer to Him and surround us with His power.

Prayer Prompt

Imagine God speaking those words from **2 Corinthians 12** over you:

"My power is made perfect in weakness." Respond to Him.

day 4
Submit to Him in Money and Trials

TOTAL TRUST

Today is _____

GO TO GOD DAILY PRAYER (p. 183) ☐

Trust

How do we become relaxed?

With His help, we open our hearts up to Him, letting Him search through our whole hearts. We stop trying to figure everything out. We acknowledge Him in all of our ways—even the things that we desperately want to control.

In other words: "Trust in the Lord with all your heart and lean not on your own understanding. In all your ways, submit to him, and he will make your paths straight."

We haven't gotten to "he will make your paths straight." That's next group session.

But I'm curious—has your heart changed, even though the study isn't over yet?

In a minute, I'm going to ask you to turn to that "Trust Tracker" that you've been using in the group session. What is it that you've been trying to trust God with? Turn to page 172 to see what you've written during the group sessions, then flip back to this page to write it down here.

Why did you choose that originally, on that first day of the study? Write what you remember here.

Right now, we're going to focus on that thing—whatever it is you're trying to trust God with—and we're going to pray, slowly, through the parts of Proverbs 3:5–6 that we've covered so far. Pray the words already written. Write what you're trusting Him with in the blank. Add more of your own prayers on the lines provided.

Let's start.

Trust in the Lord
God, I want to trust you completely with _____

With all your heart
_____ has been on my heart, and I want to love you with all of my heart.

Lean not on your own understanding
You are the only one who knows the whole story about _____

In all your ways, submit to him
I submit _____ to You, Father.

And He will make your paths straight.
Lead me. You are the only One who knows where I should go.

Amen

Prayer Prompt

Write a prayer thanking God for His constant nearness, in the past, in the present, and in the future—thank Him for helping you trust Him. Conclude your prayer with "God, I give You . . ." and then write about what it is you're trying to trust Him with.

day 5
Submit to Him in Money and Trials

Today is_____

GO TO GOD DAILY PRAYER (p. 183) ☐

Reflect and Relax

Did you gain any insight into your own responses to money and trials?

What did God reveal to you about your heart this week? Did these revelations—and His responses to you—help you feel more relaxed? Why or why not?

Have you felt yourself becoming more relaxed?

Flip back through the first five weeks of personal study. Summarize the moments you drew or wrote about as you reflected—these are in the boxes on pages 26, 53, 80, 107, and 136. If you missed one, don't sweat it! Just write down what you have.

Week 1:

Week 2:

Week 3:

Week 4:

Week 5:

Can you sense anything changing in you, even if you'd call it a "small change"? How would you describe the change in your heart to a friend or loved one?

Write a Scripture from one of the personal study days that was significant to you on a sticky note. Put it somewhere you'll see it consistently over the next few weeks (the dash of your car, bathroom mirror, the fridge, etc.).

Looking Ahead

Something to start thinking about for the next group session: How would you describe *your* part in spiritual growth? You're not supposed to "figure it all out"—but what are you supposed to do?

What's a question that came up in your days of personal study you'd want to ask the rest of the group?

Take a moment to pray for the next group meeting and the members of your group.

relaxed

session 7
And He Will Make Your Paths Straight

"For it is God who works in you to will and to act in order to fulfill his good purpose."

PHILIPPIANS 2:13

Start Here

> **LEADER:** Pray before you open your study time together, sharing whatever is on your heart with God. Invite others to pray, too.

Tracking Trust

Look through your Tracking Trust responses since week one (pages 172 –173). How has your heart changed over the course of this study? Where did you start, and where are you now? What other things do you want to trust God with—where else do you want to invite Him to work in your heart?

If you're ready, share with the group.

Definitions

Sanctification
the state of being sanctified; the state of growing in divine grace as a result of Christian commitment after baptism or conversion

Synergism
interaction of discrete agencies, agents, or conditions such that the total effect is greater than the sum of the individual effects

Watch Video

Scripture Covered in This Teaching

Proverbs 3:5–6; Philippians 2:12–13; Psalm 37:5; James
4:8; Colossians 1:29; Psalm 127:1; 1 Corinthians 3:6–7;
Ephesians 2:8–10; John 15:4–5; Galatians 5:22–23;
1 Peter 5:7; Romans 8:28–29; Revelation 21:1–5

> **LEADER:** Before starting the video, read the following aloud.

There's not going to be a test on any of this. You don't have to write something after each point.
Use the margins if you need them. Feel free to pull out your own journal, or to just sit and listen—
whatever helps you engage.

God will make our "paths straight," but He won't make everything easy.

We have active and passive roles in our spiritual growth.

God does not give us exact answers, but He will make us Christ-like choosers.

We think the only way to relax is to know what's going to happen—that's not faith.

In Heaven, there will be no more pain, or crying, or mourning.

When we trust Him with all our hearts, we join in on what He's already doing.

Go to God

Turn to the "Go to God" Session 7 on page 184 in the back of the workbook.

Discussion Questions

Spend some time with the following questions. Don't rush to get through each one. Use these questions in the way that best serves your group. Instead of going in order, you can choose to discuss the questions that are most relevant and interesting to you.

1. What stood out to you from the video—any statement or Scripture that you made sure to write down in your notes?

2. Assign each person in the group one of these verses to look up in their own Bible: **Philippians 2:12–13**, **Psalm 37:5**, **James 4:8**, **Colossians 1:29**, **Psalm 127:1**, **1 Corinthians 3:6–7**, **Ephesians 2:8–10**, and **John 15:4–5**. Spend a few minutes reading your verse quietly to yourselves, pondering this question: How does this verse describe *God's* part in the dance? How does this verse describe *our* part in the dance? Take turns reading your verses aloud and sharing your responses with each other.

3. Has this study changed your approach to growing as a follower of Jesus? Or, next time you hear a great sermon or piece of spiritual advice, what are you going to do differently?

4. Why do you think God doesn't just give us all the answers? What does that empower us to do?

5. What else would you add to the "no more" list? What does longing for heaven look like for you?

6. Flip back to your personal study pages for Session 6. How have you found yourself becoming more "relaxed" as you submit your ways to God? What has that looked like in your life?

7. Did anything arise in your thoughts or in your heart when Megan taught about "joining God in what He's already doing"? What was it? Where might He be leading you?

Closing

> **LEADER:** Remind the group this is your last week of the study. Read the closing question and ask volunteers to briefly share.

During the "Go to God" exercise, what did you hear God speaking to you? What did you write down with your non-dominant hand?

All God's People Said . . .

> **LEADER:** End the time in prayer. Pray or invite someone else to pray—the prayer below is optional.

God, You will direct our paths. And, unlike us, You've never been worried about a thing. We've spent enough time trying to figure it out ourselves. We want to join in on what You're already doing—in our hearts and in the world, in our church and with our neighbors. Give us faith to trust in You with all our hearts, lean not on our own understanding, in all our ways submit to You. Thank You for making our paths straight. *Amen*

Tracking Trust

Track Your Trust in the Lord

Session 1

What is one thing you are hoping to trust God with during this study?

Session 2

What was the one thing you wrote down last week—the one thing you're trying to trust God with during this study? After a week of prayer and study about trust, would you phrase it any differently?

Session 3

How has your perspective shifted on the one thing you're really hoping to trust God with during this study?

Session 4

In the past few weeks, has your general idea of what God wants from you changed at all? Does that thing you're trying to trust Him with look any different in light of that?

Session 5

What is it that you're trying to trust God with? Name a few of the people associated with it.

Session 6

Does the thing you want to trust God with fall into any (or several) of the ways covered in the study (grief, mistakes, risks, friendships, money, and trials)? Which "way" is it? If you think the thing you're trying to trust God with isn't covered in any of these ways, what "way" is it? (Examples: family, work, anger, future, church.)

Session 7

Look back at Tracking Trust, week 1. How has your heart changed over the course of this study? What other things do you want to trust God with? Where else do you want to invite Him to work in your heart?

Go to God

Spiritual Discipline Practices

session 1
Go to God

Read through the prayer Megan introduced during the group study. Try to incorporate it in your own daily routine.

Show Up

"Heavenly Father, I offer myself to you."

(Pause. Wait. Don't be in a hurry to move on here.)

Peel Away

"These are some of my roles and responsibilities:

I am not primarily _____, _____,

_____, _____, _____.

I am not primarily_____, _____,

_____."

As you consider your roles and responsibilities and personality, you can go through them like peeling back an onion as you think through them saying, "I am not primarily _____," (whatever is on the outside of an onion that everyone sees about you like roles you hold), then imagine peeling back another layer, while speaking over yourself, "I am not primarily _____" until you land at the core.

"At the core of who I am, I am in You Christ Jesus, and You are in me."

Let Your Mind Wander

Whatever my mind wanders to is exactly what
Jesus wants to talk to me about.

Listen and Obey

"Holy Spirit, what is it You are prompting
me to do or believe?"

(Pause. Wait. Listen.)

Amen

GOING TO GOD DAILY

The challenge is to Go to God five out of seven days each week during the study.

Reminders are indicated in each day of personal study each week.

After video ends, return to the group session for group discussion.

session 2
Go to God

During the video, listen to Megan describe the activity.

> Allow about five minutes for everyone to search their own hearts. Then, return to the group discussion.

- Write, "Search my heart" somewhere on the heart on the next page.

- God wants to meet you right where you're at—no need for a sudden surge of holiness. You don't have to put on a facade of being happier or less angry than you are in this moment.

- God already knows your heart. The Holy Spirit helps us see ourselves. Draw spokes off of the heart and, with His help, name what's inside of your heart.

- Under each one:

 1. Be honest.

 2. Listen for His truth.

 3. Wait to hear how He wants you to combine those.

> After video ends, return to the group session for group discussion.

session 3
Go to God

Think about this question. Where are you leaning: on Christ, or on yourself? Circle one. Follow along as Megan recites the lyrics to this age-old hymn of the heart.

Turn your Eyes Upon Jesus[1]

O soul, are you weary and troubled?
No light in the darkness you see?
There's light for a look at the Savior,
And life more abundant and free!

> *Refrain:*
> Turn your eyes upon Jesus,
> Look full in His wonderful face,
> And the things of earth will grow strangely dim,
> In the light of His glory and grace.

Through death into life everlasting
He passed, and we follow Him there;
O'er us sin no more hath dominion—
For more than conqu'rors we are!
His Word shall not fail you—He promised;
Believe Him, and all will be well:
Then go to a world that is dying,
His perfect salvation to tell!

> After video ends, return to the group session for group discussion.

1. Helen Lemmel, "Turn Your Eyes upon Jesus," Hymnary, https://hymnary.org/text/o_soul_are_you_weary_and _troubled.

session 4
Go to God

What makes a good apology?

An apology:

I'm sorry + for (specific thing that I did) + will you forgive me?

Let's apologize to God for something.

Tell God one thing you're sorry for—name it and ask for His forgiveness.
Submit the mistake to Him.

After video ends, return to the group session for group discussion.

session 5
Go to God

Read through the seasons as Megan explains them. Which season are you in? Circle it or put a mark next to it. Then, follow the guidance from the video.

Seasons of Life:

FALL
Change. The unknown. Not knowing what will happen next.

WINTER
Loss. Pain. Brokenness. The hardest season. Temptation to hide and isolate.

SPRING
Newness. Life. Hope. Renewal. Curiosity.

SUMMER
God's unmerited favor. Sweetness and joy. A taste of heaven.

CLOSING QUESTION

What does a person need in each of these seasons? Next to each season, write down a few things a friend could do for a person in each of these seasons.

Before you leave, write down a few names—who stood when? You don't have to catch every single person, just so you'll be able to pray for them with this new understanding this week.

> After video ends, return to the group session for group discussion.

session 6
Go to God

During the video: Listen to Megan's description of the sticky note activity.

After the video ends, set a timer for ninety seconds. Distribute two different colored packs of sticky notes to all group members. Wait until everyone is ready. Make sure everyone knows what the expectations are. One experience per sticky note.

During the first ninety seconds, you're going to write one **positive** experience per sticky note. Allow the Holy Spirit to bring things to your mind.

During the second ninety seconds, write one **negative** experience per sticky note. Allow the Holy Spirit to bring things to mind.

Here's the timeline. Write your birthday on the left side, and today's date on the right. Place the sticky notes on the timeline in chronological order.

___/___/___ ├──┤ ___/___/___
BIRTHDAY TODAY'S DATE

Look over your timeline and ask God to reveal Himself through your story. Feel free to group various sticky notes to create natural chapters. What has God been up to in your life? Write notes all throughout the page with observations about how you've grown through these experiences. What have you learned about God? What have you learned about yourself? How has God formed you more into Christ-likeness throughout your life? List your observations.

There will be time to share about your timeline after the group discussion. If you can, save the sticky notes—you'll have the opportunity to use them again during the personal study.

> After video ends, return to the group session for group discussion.

session 7
Go to God

Listen to the instructions as Megan explains the prayer.

Set a timer for 2.5 minutes. Write the most honest prayer you can with your *dominant* hand under the column titled "My Prayer." Following along with Megan's instructions on the video.

Ask the Holy Spirit to speak into the next part of the prayer—using your *non-dominant* hand, write God's response to you under the column titled "His Answer." Maybe start with what He would call you.

> After video ends, turn back to the group session. There will be a time to share what you heard God speaking to you under "His Answer" with your group after the discussion.

MY PRAYER	HIS ANSWER

Small Group
Leader's Guide

Hey!

If you are reading this, you have likely agreed to lead a group through *Relaxed*. Thank you! This could not happen without you. I don't how you're feeling about the whole thing—nervous, excited, or hopeful—but I want you to know that you don't have to figure all of this out. You don't have to do it yourself. The Holy Spirit is the teacher who works in people's hearts. You're going to do your part, and I know that means doing a lot of behind-the-scenes work, but you can *relax*. God is going to use whatever happens during this study for His glory—probably in ways you'd never expect.

Relaxed is a seven-session study built around video content and small-group interaction. As the group leader, imagine yourself as the host of a dinner party. Your job is to take care of your guests by managing all the details so that as your guests arrive, they can focus on each other and on interaction around the topic.

As the group leader, your role is NOT to answer all the questions or reteach the content—the video, book, and study guide will do most of that work. Your job is to guide the experience and cultivate your small group into a kind of welcoming teaching community. This will make it a place for members to process, question, reflect, and grow—not receive more instruction.

There are several elements in this leader's guide that will help you as you structure your study and reflection time, so follow along and take advantage of each one.

Before You Begin

MATERIALS

Before your first meeting, make sure the participants have a copy of this study guide so they can follow along and have their answers written out ahead of time. Alternately, you can hand out the study guides at your first meeting and give the group members some time to look over the material and ask any preliminary questions. During your first meeting, be sure to send a sheet around the room and have the members write down their names, phone numbers, and email addresses so you can keep in touch with them during the week.

FREE STREAMING VIDEO ACCESS

Additionally, spend a few minutes going over how to access the FREE streaming video using the code printed on the inside front cover of each study guide. Helping everyone understand how accessible this material is will go a long way if anyone (including you) has to miss a meeting or if any member of your group chooses to lead a study after the conclusion of this one!

A few commonly asked questions and answers:

Do I have to subscribe to StudyGateway? NO. If you sign up for StudyGateway for the first time using: studygateway.com/redeem you will not be prompted to subscribe, then or after.

Do I set up another account if I do another study later? NO. The next time you do a HarperChristian Resources study with FREE streaming access, all you need to do is enter the new access code and the videos will be added to your account library.

There is a short video available walking through how to access your streaming videos. You can choose to show the video at your first meeting, or simply direct your group to the HarperChristian Resources YouTube channel to watch it at their convenience.

HOW TO ACCESS FREE STREAMING VIDEOS: https://youtu.be/JPhG06ksOn8

GROUP SIZE

Generally, the ideal size for a group is between eight to ten people, which ensures everyone will have enough time to participate in discussions. If you have more people, you might want to break up the main group into smaller subgroups. Encourage those who show up at the first meeting to commit to attending the duration of the study, as this will help the group members get to know each other, create stability for the group, and help you know how to prepare each week.

PREPARING YOUR GROUP FOR THE STUDY

Before watching your first video at your first meeting, let the group members know that each session contains five days' worth of Bible study and reflection materials to complete during the week. While the personal study is optional, it will help the members cement the concepts presented during the group study time and encourage them to spend time each day in God's Word. There will be a time to remind everyone about the personal study at the end of each group session. Remember, the most important thing you can do to encourage others to do the personal study is to be excited about engaging in it yourself.

Also, invite your group members to bring any questions and insights they uncovered while reading to your next meeting, especially if they had a breakthrough moment or if they didn't understand something.

Weekly Preparation

As the leader, there are a few things you should do to prepare for each meeting:

- *Watch the video.* This will help you to become familiar with the content being presented and give you foresight of what may or may not be brought up in the discussion time. Also, in the *Relaxed* study, there is a special (and short!) additional video portion that plays right after the main teaching video—you don't have to navigate anywhere different. These are called "Go to God," and there's an activity associated with each one. It will be so helpful to you if you already know what these short video portions look like, so you can lead your group through them in the most effective way.

- *Read through the group discussion section.* This will help you to become familiar with the questions you will be asking and allow you to better determine how to structure the discussion time for your particular group.

- *Decide which questions you definitely want to discuss.* Based on the amount and length of group discussion, you may not be able to get through all of the questions, so choose four to five questions that you definitely want to cover.

- *Be familiar with the questions you want to discuss.* Every group has times when there are no responses and the question falls flat out of the gate. This is normal and okay! Be prepared with YOUR answer to the questions so you can always offer to share as an icebreaker and example. What you want to avoid is always answering the questions and therefore speaking for the group. Foremost, encourage members of the group to answer questions.

- *Remind your group there are no wrong answers or dumb questions.* Note that in many cases there will be no one "right" answer to the question. Answers will vary, especially when the group members are being asked to share their personal experiences.

- *Pray for your group.* Pray for your group members throughout the week and ask God to lead them as they study His Word.

- *Bring extra supplies to your meeting.* The members should bring their own pens for writing notes, but it's a good idea to have extras available for those who forget. You may also want to bring paper and additional Bibles.

Structuring the Discussion Time

You will need to determine with your group how long you want to meet each week so you can plan your time accordingly. Generally, most groups like to meet for either sixty minutes or ninety minutes, so you could use one of the following schedules:

SECTION	60 MINUTES	90 MINUTES
Introduction (members arrive and get settled; leader reads or summarizes introduction)	5 minutes	5 minutes
Watch Video and Go to God (watch the teaching video together and take notes)	30 minutes	30 minutes
Group Discussion (discuss the Bible study questions you selected ahead of time)	25 minutes	45 minutes
Closing Prayer (pray together as a group and dismiss)	5 minutes	10 minutes

As the group leader, it is up to you to keep track of the time and keep things moving along according to your schedule. You might want to set a timer for each segment so both you and the group members know when your time is up. (Note that there are some good phone apps for timers that play a gentle chime or other pleasant sound instead of a disruptive noise.)

Don't be concerned if the group members are quiet or slow to share. Silence is not the enemy! Sometimes we need it to help us process. People are often quiet when they are pulling together their ideas, and this might be a new experience for them. Just ask a question and let it hang in the air until someone shares. You can then say, "Thank you. What about others? What came to you when you watched that portion of the video?"

Spiritual Discipline Practices

There are two sections referred to throughout this study: Tracking Trust and Go to God. Both of these sections are located at the back of each study guide.

Tracking Trust is a weekly practice of translating what your heart is dealing with into words on a page where you can follow the transformation of your heart in trusting the Lord with all things. This exercise is simple yet profound and something everyone can carry on in a journal or other format well after this study. Be sure you encourage your group members to engage with this short, simple, but highly-effective weekly activity.

Go to God is a dual impact section. The first week includes a prayer I walk you through in the first video. This prayer is meant to be repeated throughout the five days of personal study each week. There are check-box reminders to pray on each day of the personal study section every week. The second impact of the Go to God section involves the six other spiritual discipline practices I introduce weekly at the end of each video. You will want to instruct your group ahead of time to locate this section in the back of the guide. Your group members will turn to this section during this end "Go to God" portion of the video each week. This is where individual space is provided to engage the spiritual discipline practice I describe or demonstrate in the video.

Group Dynamics

Leading a group through *Relaxed* will prove to be highly rewarding both to you and your group members. However, this doesn't mean you will not encounter any challenges along the way! Discussions can get off track. Group members may not be sensitive to the needs and ideas of others. Some might worry they will be expected to talk about matters that make them feel awkward. Others may express comments that result in disagreements. To help ease this strain on you and the group, consider the following ground rules.

> When someone raises a question or comment that is off the main topic, suggest you deal with it another time, or, if you feel led to go in that direction, let the group know you will be spending some time discussing it.

If someone asks a question you don't know how to answer, admit it, and move on. At your discretion, feel free to invite group members to comment on questions that call for personal experience.

If you find one or two people are dominating the discussion time, direct a few questions to others in the group. Outside the main group time, ask the more dominating members to help you draw out the quieter ones. Work to make them a part of the solution instead of the problem.

When a disagreement occurs, encourage the group members to process the matter in love. Encourage those on opposite sides to restate what they heard the other side say about the matter, and then invite each side to evaluate if that perception is accurate. Lead the group in examining other Scriptures related to the topic and look for common ground.

When any of these issues arise, encourage your group members to follow these words from the Bible: "Love one another" (John 13:34), "If it is possible, as far as it depends on you, live at peace with everyone" (Romans 12:18), and "Be quick to listen, slow to speak and slow to become angry" (James 1:19). This will make your group time more rewarding and beneficial for everyone who attends.

And listen—

I'm praying for you.

I'm praying that you'll have grace, and patience, and the time you need to get things ready.

I'm praying that this is a joyful experience for you.

I'm praying that when everything goes well, you thank Him for His presence.

And that when everything *doesn't*, you thank Him anyway.

Most of all, I'm praying that you are drawn closer to Him during the course of this study, and that you find, at the end of it, that you trust Him more.

Thank you for doing this.

Session by Session Overviews

Session 1
Trust in the Lord

Scripture covered in this session: Proverbs 3:5–6; Genesis 3:7–13; Genesis 2:25; Romans 5:8

Discussion Question choices / notes:

Session 2
With All Your Heart

Scripture covered in this session: Matthew 22:37; Proverbs 3:5-6, 4:23; Mark 9; Jeremiah 29:13; John 15; Romans 7 (referred to in Go to God)

Discussion Question choices / notes:

Session 3

Lean Not on Your Own Understanding

Scripture covered in this session: Proverbs 3:5–6; Philippians 2:13; Revelation 4; Isaiah 6; Luke 12:2; Hebrews 4:13–16; 2 Corinthians 5:21; Romans 6:23; Hebrews 12 (referred to in Go to God)

Discussion Question choices / notes:

Session 4

Submit to Him in Grief and Mistakes

Scripture covered in this session: Proverbs 3:5–6; 1 Corinthians 15:23; 1 Thessalonians 4; Romans 8; Psalm 34:18; John 11:35; Isaiah 53:3; Psalm 51

Discussion Question choices / notes:

Session 5
Submit to Him in Risk and Friendships

Scripture covered in this session: Proverbs 3:5–6; Genesis 1:26–28, 2:18;
Ephesians 3:14–21; John 15:15; Romans 12; John 17; Matthew 7:12; Acts 20:35

Discussion Question choices / notes:

Session 6
Submit to Him in Money and Trials

Scripture covered in this session: Proverbs 3:5–6; Matthew 6:19–25; Psalm 24:1;
James 1:2–4; 2 Corinthians 12:7–10

Discussion Question choices / notes:

Session 7
And He Will Make Your Paths Straight

Scripture covered in this session: Proverbs 3:5–6; Philippians 2:12–13; Psalm 37:5; James 4:8; Colossians 1:29; Psalm 127:1; 1 Corinthians 3:6–7; Ephesians 2:8–10; John 15:4–5; Galatians 5:22–23; 1 Peter 5:7; Romans 8:28–29; Revelation 21:1–5

Discussion Question choices / notes:

Megan Fate Marshman

As an international speaker at churches and conferences, Megan Fate Marshman is a leading voice to this generation. She has devoted her life to loving God and overflowing His transformational love to others. She's finishing her Doctorate in Ministry as she serves as a teaching pastor at Willow Creek Community Church and the Director of Women's Ministries at Hume Lake Christian Camps. Megan lives in Southern California and loves adventuring and sharing the love of Jesus with her two boys.

Companion Book To Enrich Your Study Experience

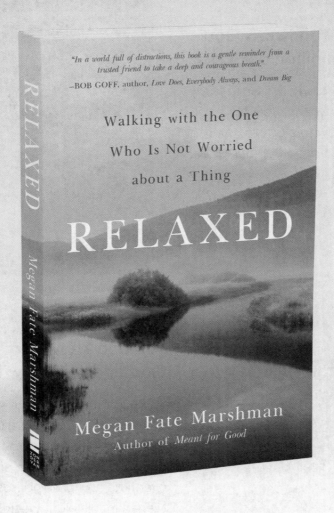

Available wherever books are sold

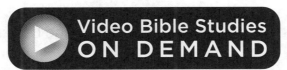

From the Publisher

GREAT STUDIES

ARE EVEN BETTER WHEN THEY'RE SHARED!

Help others find this study:

- Post a review at your favorite online bookseller.

- Post a picture on a social media account and share why you enjoyed it.

- Send a note to a friend who would also love it—or, better yet, go through it with them.

Thanks for helping others grow their faith!